FRANCIS BACON

THE HUMAN BODY

DAVID SYLVESTER

UNIVERSITY OF CALIFORNIA PRESS

BERKELEY LOS ANGELES LONDON

Hayward Gallery

sbc

Jointly published by the Hayward Gallery and the University of California Press on the occasion of the exhibition *Francis Bacon: The Human Body*, organized by the Hayward Gallery, London, 5 February – 5 April 1998

Exhibition curated by David Sylvester

Exhibition organized by Martin Caiger-Smith, assisted by Gilly Paget
Architectural consultant: Daniella Ferretti

Catalogue designed by Peter Campbell
Production coordinated by Uwe Kraus GmbH
Printed in Italy by Sosso, Turin

Front cover: *Study from the Human Body*, 1949 (detail) (Cat. 3),
National Gallery of Victoria, Melbourne, Australia
Back cover: *Triptych – Studies of the Human Body*, 1970
(detail from right-hand panel) (Cat. 17),
Marlborough International Fine Art

Photographs: page 2 © Henri Cartier-Bresson/Magnum Photos;
page 94 © John Edwards

ISBN 1 85332 175 3 (pbk) (Hayward Gallery edition)
ISBN 0 520 21539 7 (pbk) (University of California Press edition)

CONTENTS

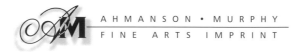

AHMANSON • MURPHY
FINE ARTS IMPRINT

THE AHMANSON FOUNDATION

has endowed this imprint

to honor the memory of

FRANKLIN D. MURPHY

who for half a century

served arts and letters,

beauty and learning, in

equal measure by shaping

with a brilliant devotion

those institutions upon

which they rely.

PREFACE

GIVEN FRANCIS BACON's pre-eminence in twentieth-century British art and the number of important exhibitions devoted to the artist around the world in recent decades, there have been surprisingly few showings of his work in Britain, the last major public exhibition having been the retrospective at the Tate Gallery in 1985.

The Hayward Gallery has long hoped to present an authoritative exhibition of Bacon's work. The present exhibition evolved through discussions with David Sylvester, who has been writing about Bacon for nearly fifty years, whose volume of interviews with him has been widely translated and who has curated major exhibitions of his work in Venice, Paris and Munich. He has conceived especially for the Hayward's lower galleries an exhibition which, while modest in scale, focuses on the core of Bacon's work throughout his career. Unlike previous Bacon exhibitions, this one excludes images of heads and animals and landscapes in order to concentrate on his exploration of the human body.

Francis Bacon: The Human Body consists of five triptychs and eighteen single canvases, dating from 1943 to 1986. The assembly of such an important group of works is a testament to the enormous generosity of our lenders, both public and private, in this country and abroad. Their belief in and willingness to support our project is deeply appreciated. We are grateful, too, to Lord Gowrie, Chairman of the Arts Council of England, and to M. Jean Jacques Aillagon, President of the Centre Georges Pompidou, for their support of key loan requests. We have been helped enormously, in myriad ways, by the

Marlborough Gallery, and by Marlborough Fine Art International, and in particular by Miss Valerie Beston. We thank her, and her assistant Kate Austin, for their enthusiastic and invaluable collaboration. We are grateful, as well, to Gilbert Lloyd of the Marlborough Gallery, to Ivor Braka, to Larry Gagosian and to Massimo Martino for their help in obtaining loans. We extend particular thanks to Nikos Stangos for his advice on the catalogue. Above all, we are indebted to David Sylvester, for devoting himself so wholeheartedly to the project, and for guiding it with his characteristic precision, humour and extraordinary aesthetic sense.

Susan Ferleger Brades
Director, Hayward Gallery

Martin Caiger-Smith
Head of Exhibitions

IMAGES

OF

THE HUMAN

BODY

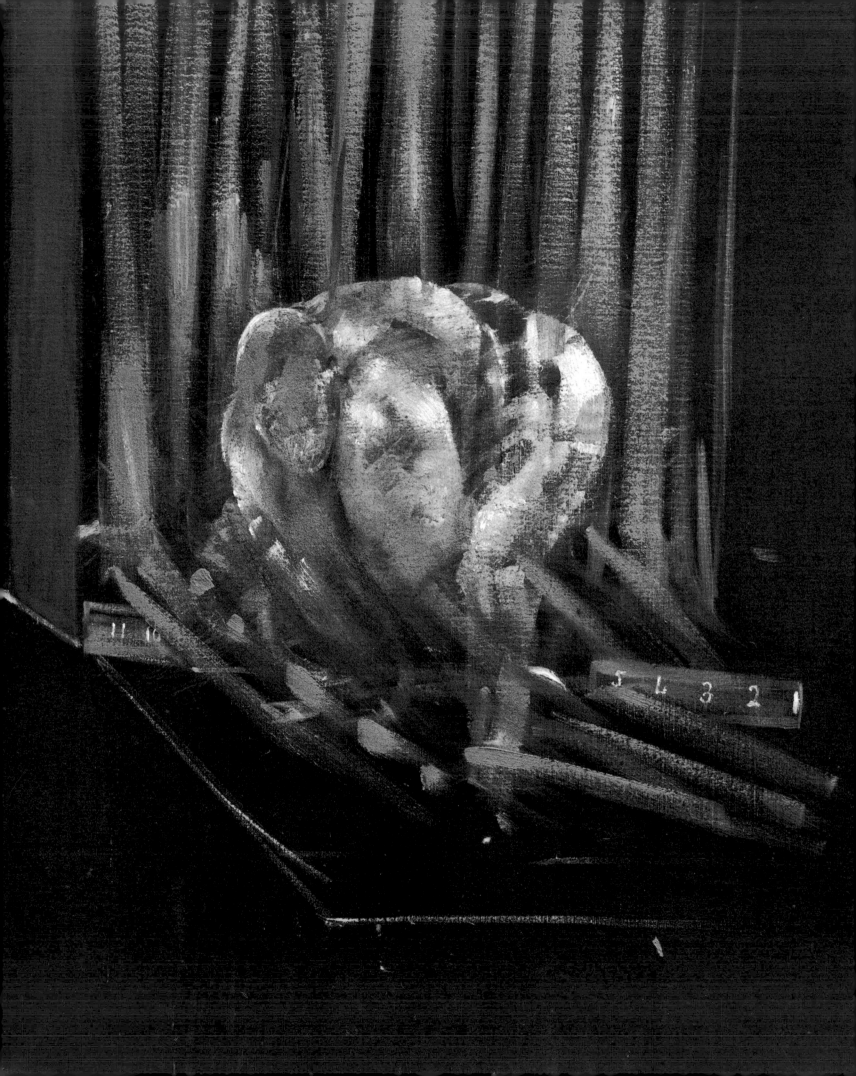

'I THINK I have seen figures by him, of which it was very difficult to determine whether they were in the highest degree sublime or extremely ridiculous.' Thus Reynolds of Michelangelo.

<div align="right">(The Idler, LXXIX, 20 October 1759)</div>

Cat. 5
Study for Nude, 1951
(detail)

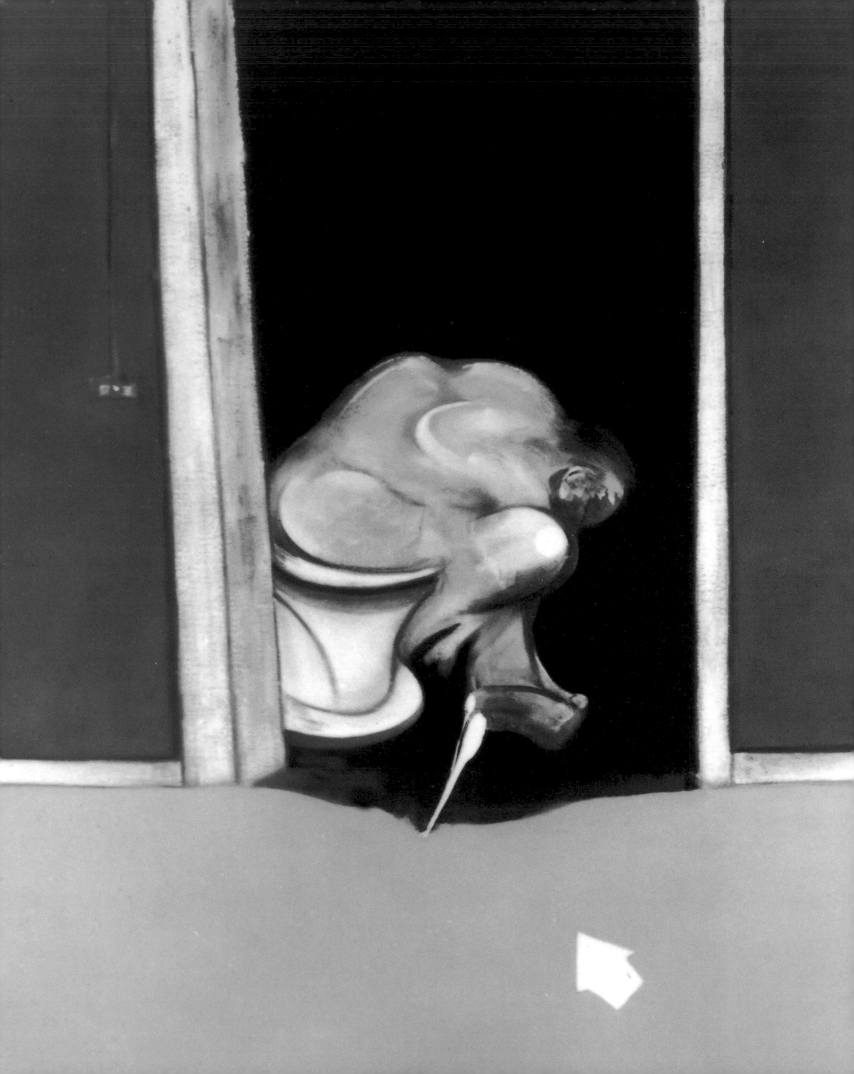

BACON has lately survived exposure to two vast museum spaces that could have been killers – the Centre Pompidou in Paris and the Haus der Kunst in Munich. They brought out a grandeur in the work that had tended to be less manifest than its expressiveness and its vitality. Some paintings seemed to possess a Matissean severity and serenity that had not previously been suspected. Canvases hung in the two daylit areas of the Paris showing had a vibrancy that made Bacon look as much a colourist as a dramatist: the grisaille paintings of the late 1940s and early Fifties had a hushed lyricism; the monumental triptychs of the 1970s seemed to derive their power from their abstract qualities: in the great black triptych recording George Dyer's death alone in his hotel room, this document about pain – the protagonist's pain, the artist's pain – what mattered most was the density and incisiveness of the black and maroon quadrilateral shapes.

Where the constructed setting in Paris provided a relatively neutral modernist framework for the paintings, the grandiose neo-classical spaces at Munich were as much a theatre as a set of galleries. You saw a picture in another room through a portal on which it was centred and it looked like a Velázquez hanging in the Prado.

Cat. 18
Triptych May–June 1973, 1973
(detail from left-hand panel)

BACON's choice of pictures from the National Gallery's collection for his exhibition in 1985 in the series called *The Artist's Eye* showed a strong bias towards serene and monumental works such as Masaccio's *Virgin and Child* and Seurat's *Baignade*. He did have a still life and a landscape by van Gogh, but there was no figure-painting that was at all expressionistic or even vigorously dramatic: Rubens' *Brazen Serpent* had been on the list of possibles but was eliminated. Another artist left out in the end – in this case one who would have fitted in – was Raphael. He was left out because there was no particular example that Bacon loved enough, but, had the NG's collection included the tapestry cartoons, which he often went to see at the Victoria & Albert Museum, I feel sure that *The Miraculous Draught of Fishes* would have been in the exhibition.

Something in the hang came as a revelation to me. In the middle of the best wall Bacon placed three great nudes: Degas' pastel, *Woman Drying Herself*, in the centre, flanked by Velázquez' *Rokeby Venus* and the Michelangelo *Entombment*. Degas was the marriage of Velázquez and Michelangelo and thus Bacon's key painter.

It was a revelation because of the way it made an unwitting art-historical point, not because there had ever been any doubt about how crucially those three artists had influenced Bacon. For example, in his earliest surviving image of a nude, *Study from the Human Body*, 1949, the treatment of the spine clearly reflects his fascination with how the top of the spine in *Woman Drying Herself* 'almost comes out of the skin altogether', as he put it, making us 'more conscious of the vulnerability of the rest of the body'. In other respects this particular Bacon nude is less like a Degas than many others in that the realisation is more smudgy and atmospheric and evanescent, less incisive, than in later works. It is wonderfully tender and mysterious in its rendering of the space between the legs and its modelling of the underside of the right thigh. Its use of grisaille is breathtaking. None of Bacon's paintings puts the question more teasingly as to whether he is primarily a painterly painter or an image-maker. Does this work take us by the throat chiefly because of its lyrical beauty or because of the elegiac poignancy of its sense of farewell?

Cat. 3
*Study from the
Human Body*, 1949
(detail)

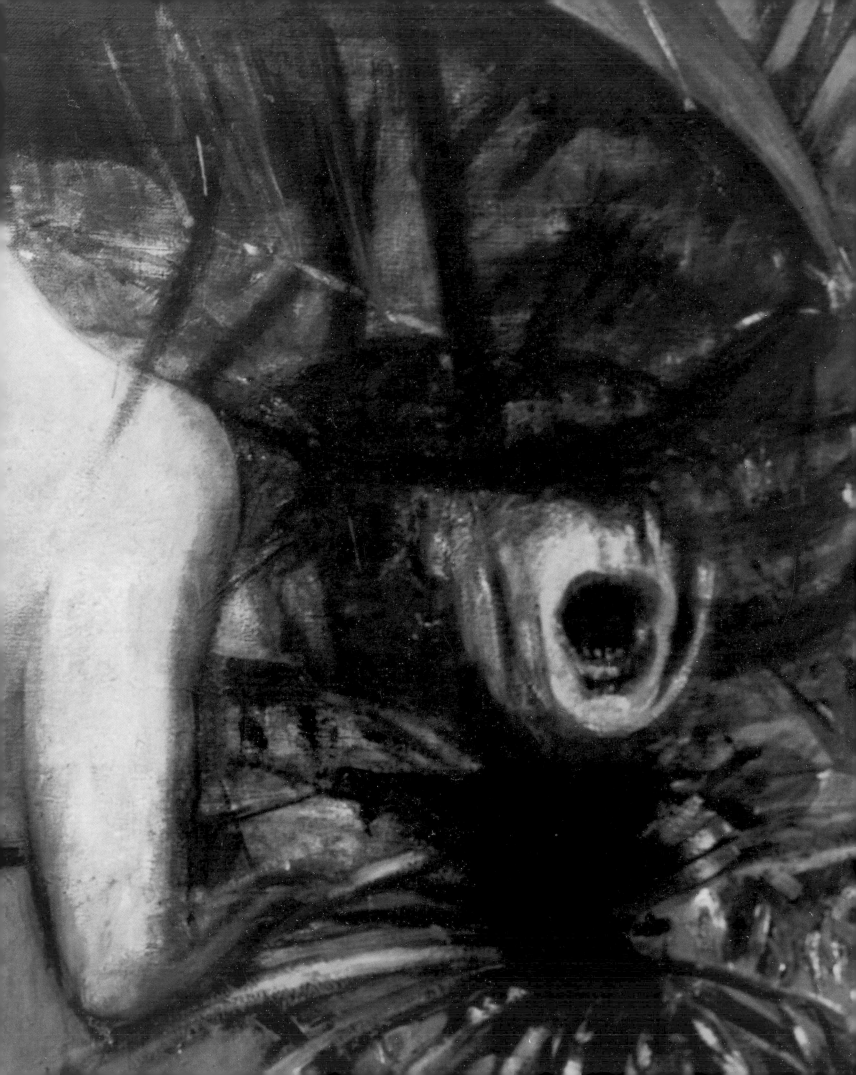

THERE were two images of the human cry that haunted Bacon, one from Eisenstein's Odessa Steps sequence in *Battleship Potemkin*, the other from Poussin's *Massacre of the Innocents* at Chantilly. The first is the cry of a nanny, her glasses broken and her face streaming with blood, trying to protect a baby in its pram from the advancing infantry, the second is the cry of a mother interposing herself between a baby on the ground and a swordsman about to strike. Both cries are induced by the same situation – the threat of infanticide by soldiery.

Bacon was the son of an army captain who was himself the son of a captain and grandson of a general. He grew up in fear of his father, who despised him as a weakling. He had a lifelong devotion to his nanny. In fact, she lived with him in her old age, including the time when he was painting those cries.

Cat. 2
Figure Study II, 1945–46
(detail)

I HAVE BEEN looking at a coffee-table book about Bacon portraits in which the plates are all heads in close-up reproduced in colour about the size they are in the actual paintings. They fill me with nausea. They appear to be the outcome of an infliction of damage, of gratuitous and merciless deformation, which they don't when seen in the original. It might be because, when looked at in a book open on a table, they are very much closer than when looked at on a wall, but I do not think it is that, because I doubt whether they would have that sickening effect were they in black and white. The nausea arises from the fact that these coloured same-size reproductions under our noses have a spurious resemblance to the originals but, lacking as they do the low relief and the inner luminosity of paint, are dead. Something grand is thereby turned into something gruesome.

Cat. 8
Study for Figure II, 1953/55
(detail)

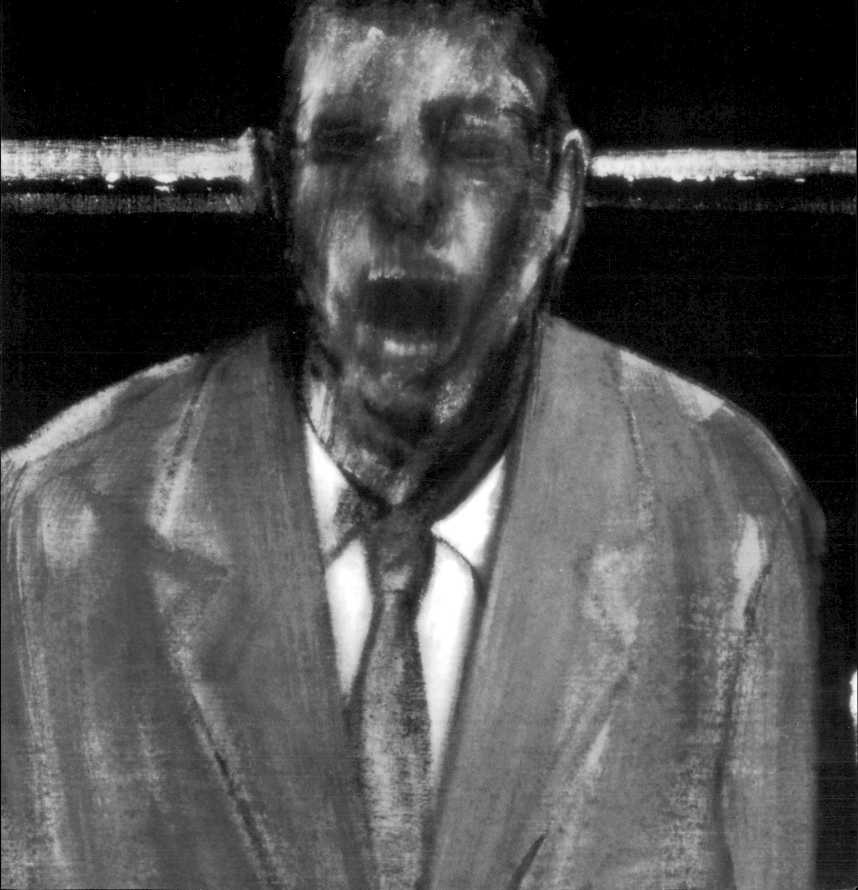

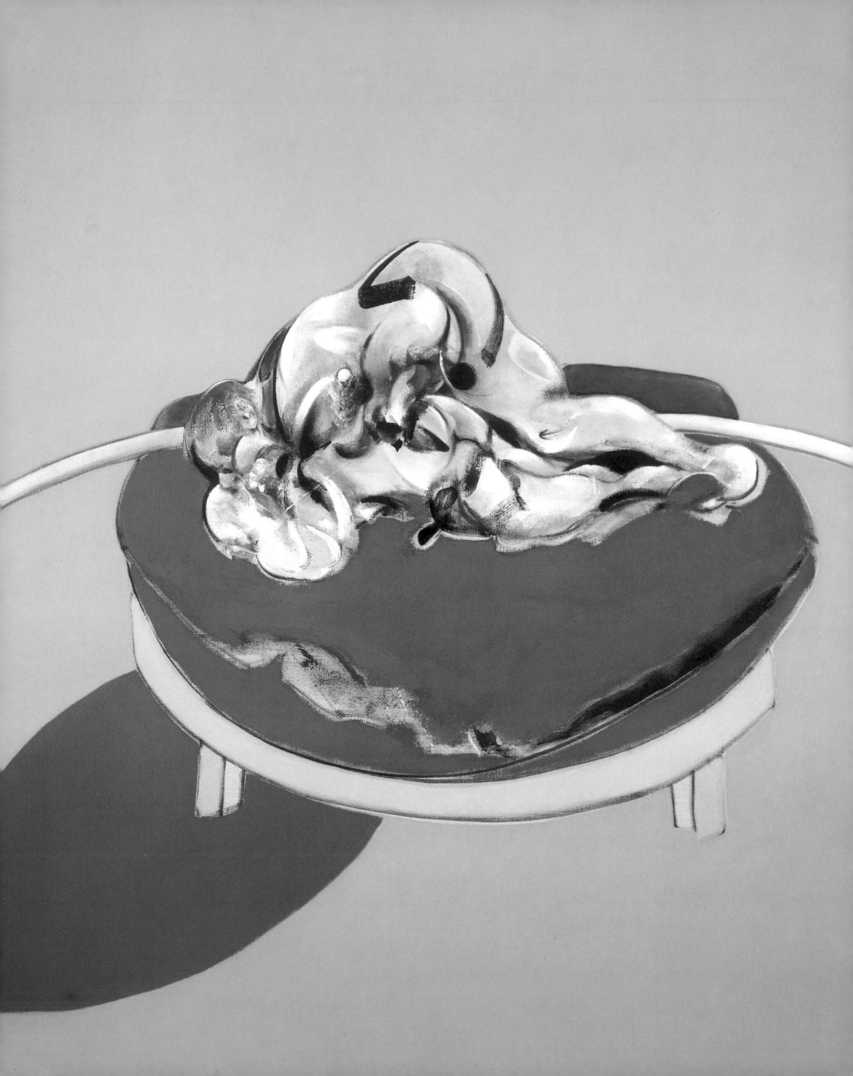

PICASSO; Brancusi; Léger, Duchamp and Picabia; Klee, Ernst and Schwitters; Arp, Miró, Calder and Giacometti; Magritte and Dalí; Dubuffet, de Kooning and Guston; Rauschenberg, Lichtenstein, Oldenburg, Warhol, Johns and Koons: all have produced witty or humorous works of art. The twentieth century likes its art to be jokey.

Bacon, who was famous for enjoying and engendering huge hilarity in his social life, created an art that was always resoundingly solemn.

But he was not quite alone in his solemnity; he was in the company of Newman and Rothko and Still and Pollock. Those four contemporaries of his are grouped by Robert Rosenblum as the exponents of 'The Abstract Sublime'. And Bacon's role in painting has been that of the one great exponent in our time of the Figurative Sublime.

Cat. 16
Triptych – Studies from the Human Body, 1970
(detail from centre panel)

WHILE Bonnard is not one of the artists eulogised in Bacon's published interviews, my notes on conversations in the 1950s show that at that time he was the twentieth-century painter Bacon preferred — because of the handling of the paint. He also greatly admired Soutine for his paint, but only in the work of the Céret period.

BACON's work is not companionable. It is quite often shown alongside paintings and/or sculptures by Giacometti, which is reasonable without being especially helpful to either artist, and sometimes with Balthus as well, which makes no sense whatever. It is occasionally shown with de Kooning and/or late Guston, comparisons that are by no means irrelevant but are not very illuminating, though they are more so than juxtapositions with either Freud or Andrews or Auerbach.

The artist I want to see alongside Bacon — despite the generation gap — is Warhol. Which Warhols? Car crashes; a large canvas with a head of Marilyn isolated in the middle; certain Jackies; some of the *Most Wanted Men* and *Ladies and Gentlemen* series; a head of Nelson Rockefeller with a battery of microphones: things that show the transfiguration of photographic images by accidental or seemingly accidental defacements that denote nothing but suggest a great deal.

Cat. 7
Study of a Nude, 1952–53
(detail)

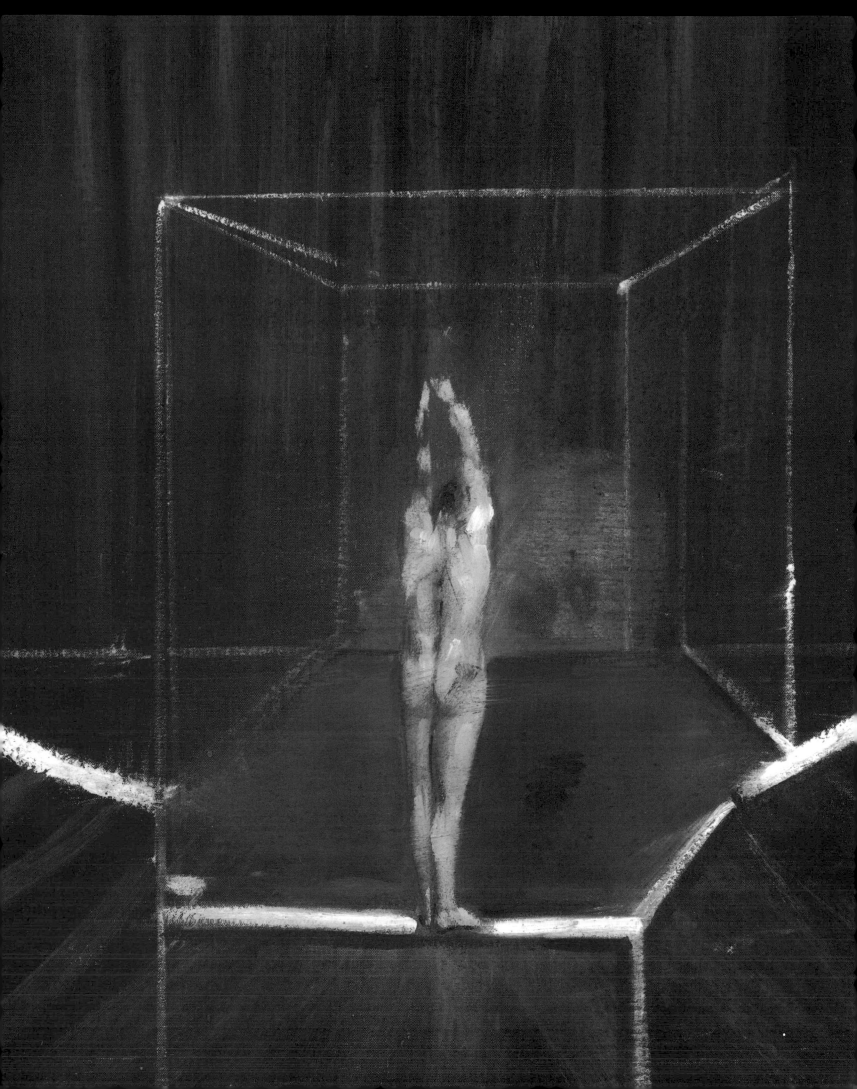

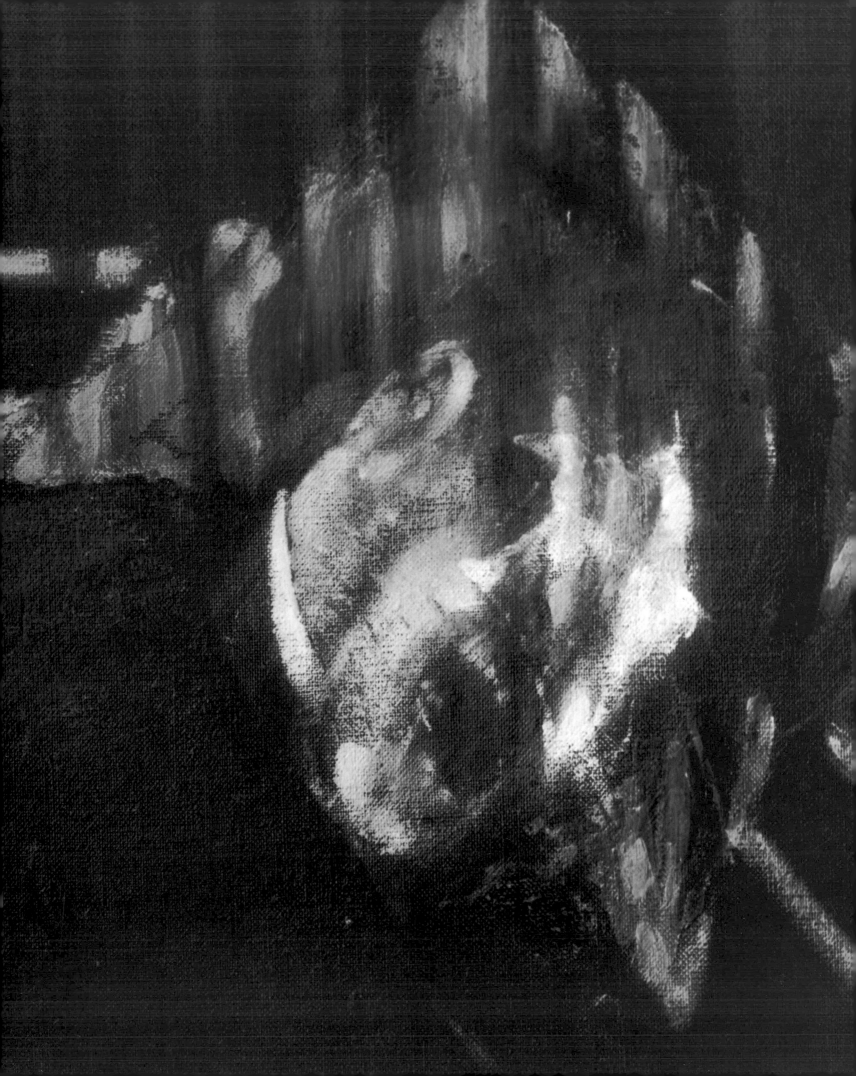

ATRIPTYCH of heads forming a sort of tragic strip culminates in an image of a 'broken' man. But what conveys his absolute defeat? Something more than the bowed head on the pillow, the hunching of the shoulders, the wailing mouth, the hand lifted in grief, something more than the conventional miming of despair. It is how the paint is smeared across the features of the face.

The smearing means disintegration: the face is already 'food for worms', the skull seen now 'beneath the skin'. The smearing means destruction: the face is wounded, shattered.

The smearing means obliteration: the face is obscured by the lifted hand, and the hand may be lifted in pain, or to ward off an attack, or to claw at nose and mouth and eyes as if in an effort to wipe them away, to rub out an identity.

The smearing means all this, but what these meanings involve conveys itself before there has been time to become aware of meanings. The meanings, all of them, lie in the paint, and they are in the paint not latently but in the impact of the paint upon our senses, on our nerves.

Nothing in these paintings is more eloquent than the paint itself.

THE FOREGOING discussion of *Three Studies of the Human Head*, 1953, Bacon's first triptych of heads, was written in 1957 and seems to me to say something about how Bacon's paint works. But the piece in which it was first published is largely shaming. It is a sort of prose poem made up of brief, disparate, highly-polished utterances (rather like those in the present text but more gnomic and incantatory). A first version was published in a French exhibition catalogue and a second shortly after in a British literary and political monthly where it was entitled 'In Camera', as a salute to Sartre's *Huis Clos*. It said things like 'Somebody seen in a fleeting moment in a world without clocks.'

For such excesses I was mercilessly taken apart in a letter from my friend Helen Lessore. Helen's manner was usually rather pi, but it concealed a waspish sense of humour which on this occasion she

Fig. 1
Three Studies of the Human Head, 1953
(detail from right-hand panel)
oil on canvas
each panel 61 x 51 cm
Private collection

unleashed. Her letter took the form of a devastating parody of my piece. One of her conceits gave a new meaning to the popes, those fraught images of a father-figure who could be seen as a stand-in for the parent Bacon both feared and desired. I had said: 'One of the popes is alone with a tasselled golden cord hanging from the ceiling. His right arm is raised, and bared to the elbow. He seems to have been amusing himself by making the cord swing to and fro like a pendulum.' The parody proposed that the pendant cord was a lavatory chain.

WHY DID Bacon persist, whether doing figures or heads, in painting on the same scale – around three-quarters life size? He proved in the 1944 *Crucifixion* triptych and in *Study of a Nude* of 1952–53 – the back view of a man with arms raised – that he was capable of working very successfully on other scales, in the latter case about one-eighth life size. And there is no doubt that commercially it would have been advantageous to vary the scale.

Was it that he felt that painting was so difficult in our time that he didn't want to complicate things further? Was it that he didn't want to lower himself by being accommodating?

BACON always claimed that he greatly envied the sort of collaboration that Eliot enjoyed with Pound in writing *The Waste Land*. 'I think it would be marvellous to have somebody who would say to you, "Do this, do that, don't do this, don't do that!" and give you the reasons. I think it would be very helpful.... I long for people to tell me what to do, to tell me where I go wrong.'

Bacon did paint two pictures in collaboration with his best friend, Denis Wirth-Miller, in the early 1950s. But he also dreamed of working in collaboration with an artist he did not know well, Karel Appel,

Fig. 2
Pope, 1954
(detail)
oil on canvas
152.5 x 116.5 cm
Private collection

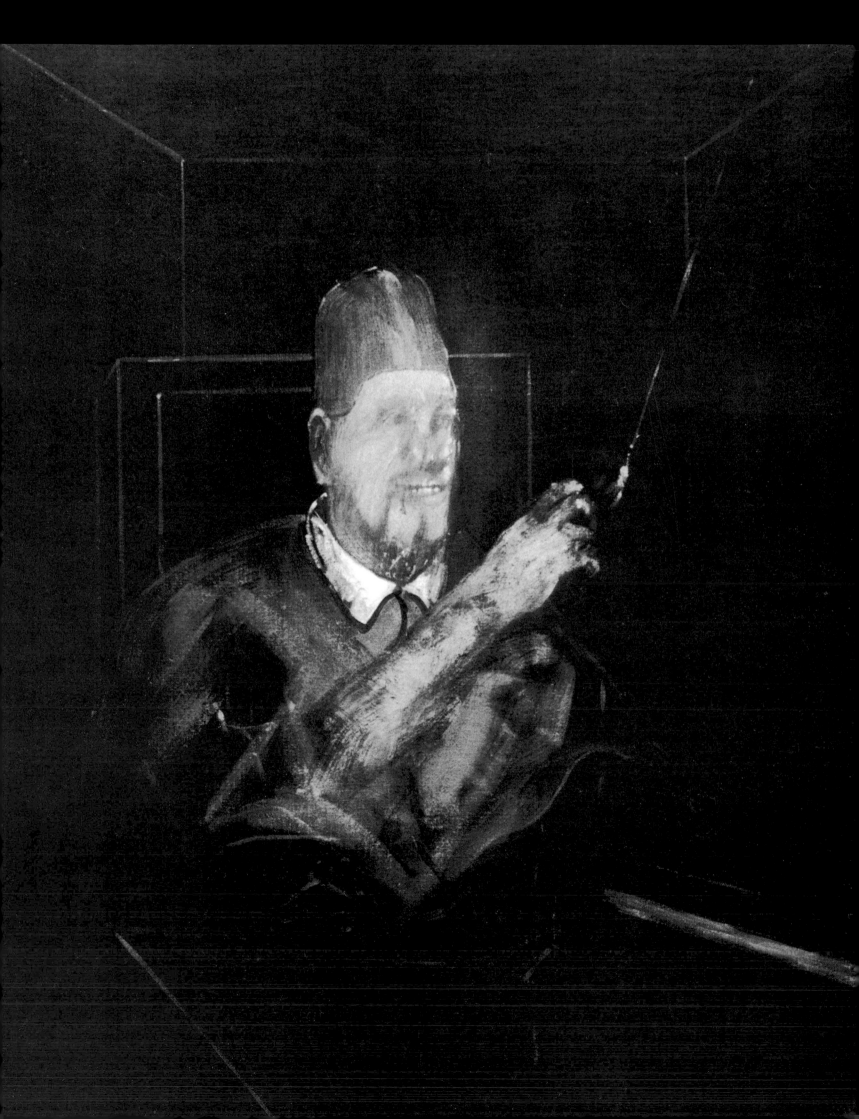

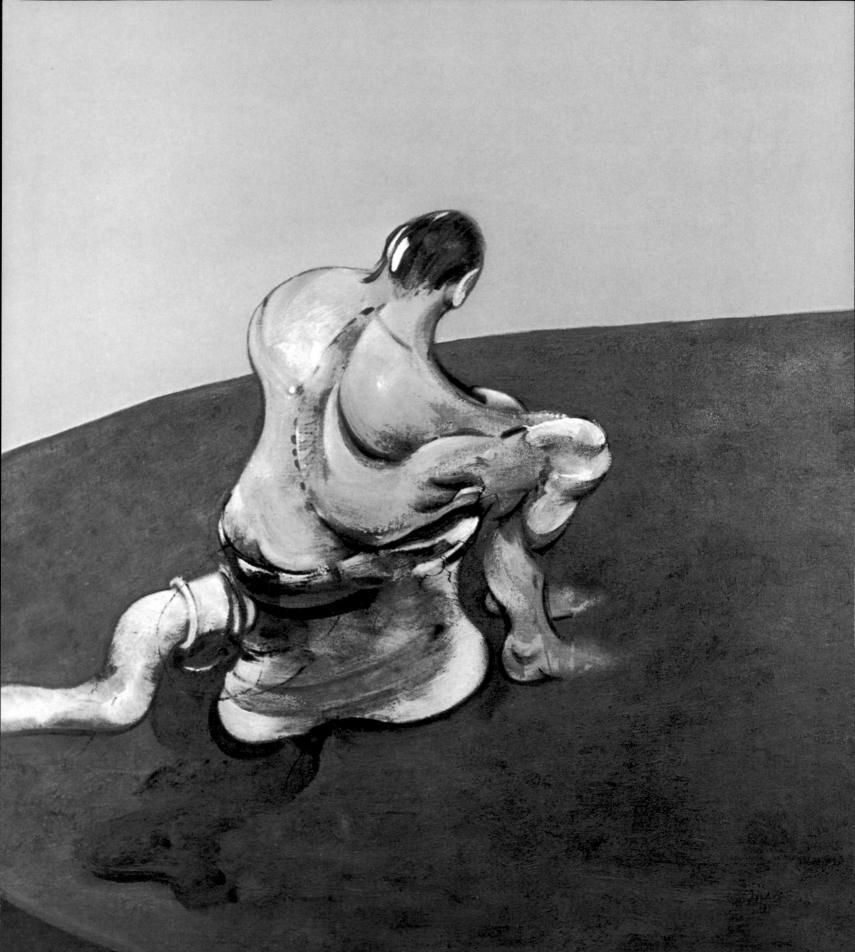

to whom he took a great liking. It never went beyond talk. Many years later I asked Appel whether they had ever even started a collaborative painting. He said it had never happened because they could never make up their minds who was to go first; by the time they did decide, they were always too drunk to make a start.

THERE ARE times in the history of art when a lot of people are working well, breaking new ground. The years following the Second World War saw the emergence as major figures of Gorky, de Kooning, Rothko, Newman, Pollock, Dubuffet, Giacometti Mark II and Bacon. And it seems to me that 1945-53 was one of the two peak periods of Bacon's career.

The other, I think, covered the sequence of a dozen big triptychs which he painted between 1970 and 1976, virtually all of them studies of the male nude, most of them portraying George Dyer, some of them avowedly realised in a conscious wish to exorcise the pain of Dyer's death.

IN THE great triptych of 1973 commemorating on a black ground George Dyer's death in his hotel bedroom, the left-hand panel records the fact that he expired seated on the lavatory. And in the earliest triptych in which Dyer appeared, three views of the same nude figure painted in 1964, the left-hand panel shows him seated on the lavatory.

This is not the only instance of a kind of prophecy in Bacon's work. In Martha Parsey's documentary film, *Model and Artist: Henrietta Moraes and Francis Bacon*, the model speaks of *Lying Figure with Hypodermic Syringe*, 1963: 'When Francis painted a hypodermic syringe in my arm I'd never really heard of drugs... later... I certainly

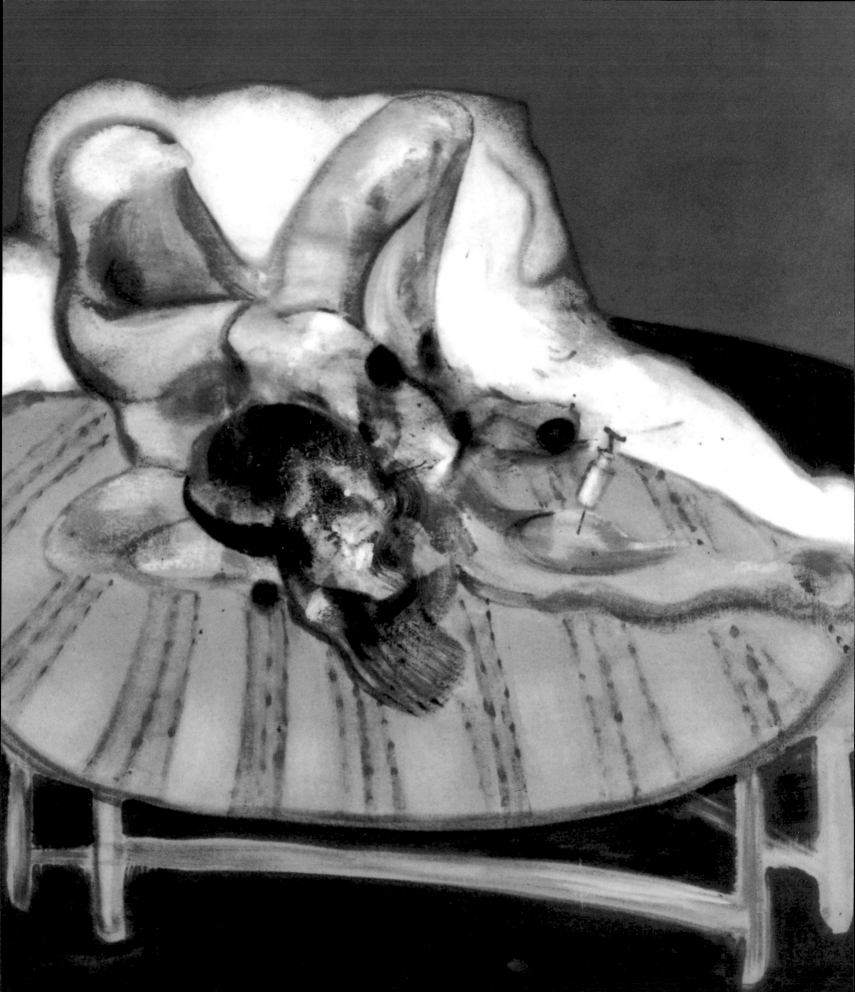

did get to know what a hypodermic was. But he put it there a good ten years before I'd even thought of it.' Bacon in fact didn't think about the heroin. 'I've used the figures lying on beds with a hypodermic syringe as a form of nailing the image more strongly into reality or appearance. I don't put the syringe because of the drug that's being injected but because it's less stupid than putting a nail through the arm, which would be even more melodramatic. I put the syringe because I want a nailing of the flesh onto the bed.'

He made the same show of indifference to the practical implications of props in his pictures in his explanation of the presence of a swastika on the arm of a figure in the 1965 *Crucifixion* triptych, a detail which was widely interpreted as being ideologically significant. 'I wanted to put an armband to break the continuity of the arm and to add the colour of this red round the arm. You may say it was a stupid thing to do, but it was done entirely as part of trying to make the figure work – not work on the level of interpretation of its being a Nazi, but on the level of its working formally.'

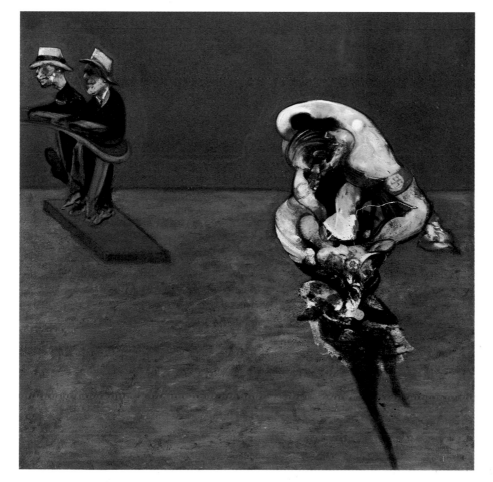

Fig. 3
Crucifixion, 1965
(detail from right-hand panel)
oil on canvas
each panel 198 x 147.5 cm
Staatsgalerie Moderner Kunst, Munich

Cat. 11
*Henrietta Moraes
(Lying Figure with
Hypodermic Syringe)*, 1963
(detail)

I T IS HARD to think of anyone who painted more self-portraits. Bacon painted dozens, mostly small canvases of his head. Usually three are put together to form a triptych; sometimes one appears as a solo canvas or as a unit in a triptych along with other peoples' heads.

Self-portraits as a genre have traditionally been heads or busts or half-lengths, occasionally three-quarter-lengths, very rarely full-lengths. That is largely because they are generally painted from mirrors. Bacon painted from photographs and realised a substantial number of full-length self-portraits. Beginning in 1956 – with an image Quasimodo-like in face and figure – he produced seventeen. That count includes the *Sleeping Figure* of 1974 painted from a photograph of him stretched out on a hospital bed. It also includes three items which in fact constitute *Study for Self-Portrait – Triptych*, 1985–86. This has a look of having been undertaken as a kind of *summa* of all the artist's activity as a self-portraitist. Such enterprises usually fail. This work seems to me not only Bacon's supreme achievement in self-portraiture but the finest thing he did during the last fifteen years of his life. It is in the line of those self-portraits by old artists which are merciless acts of self-recognition, and it has a kind of grandeur which recalls the unaffected, easygoing grandeur that Bacon had as a man.

Cat. 23
Study for Self-Portrait – Triptych, 1985–86
1985–86
(detail from centre panel)

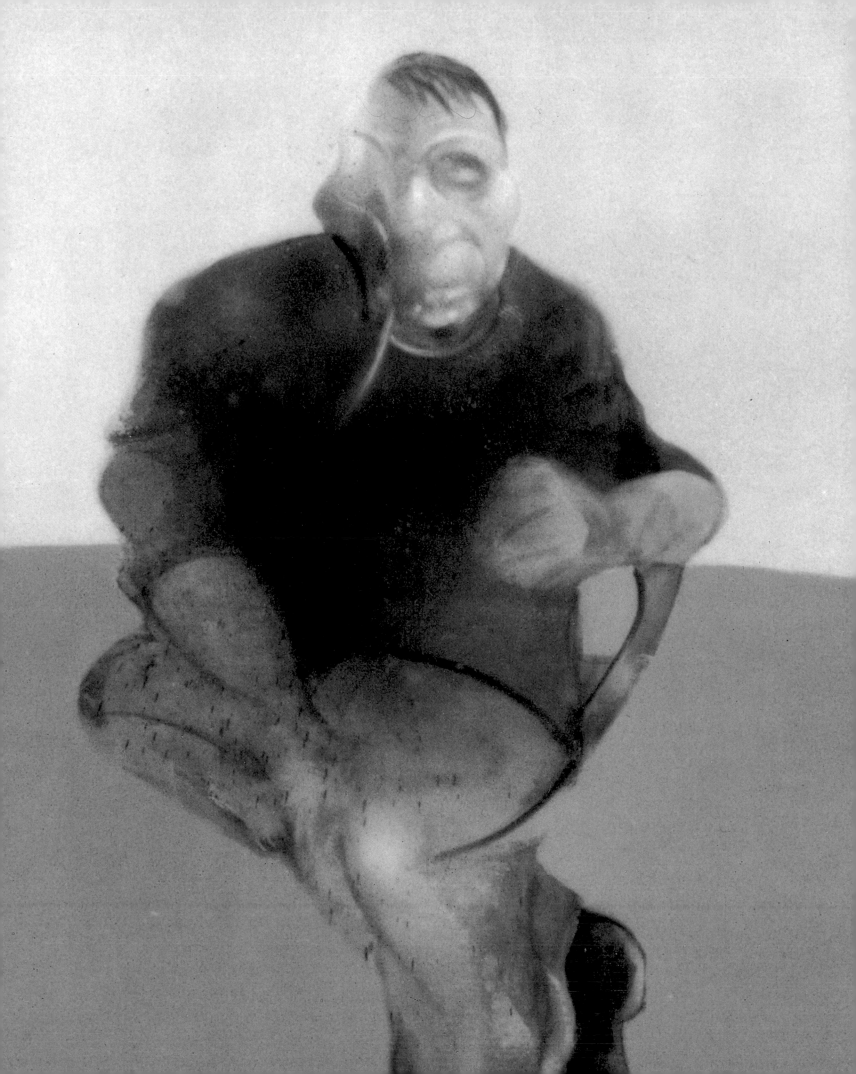

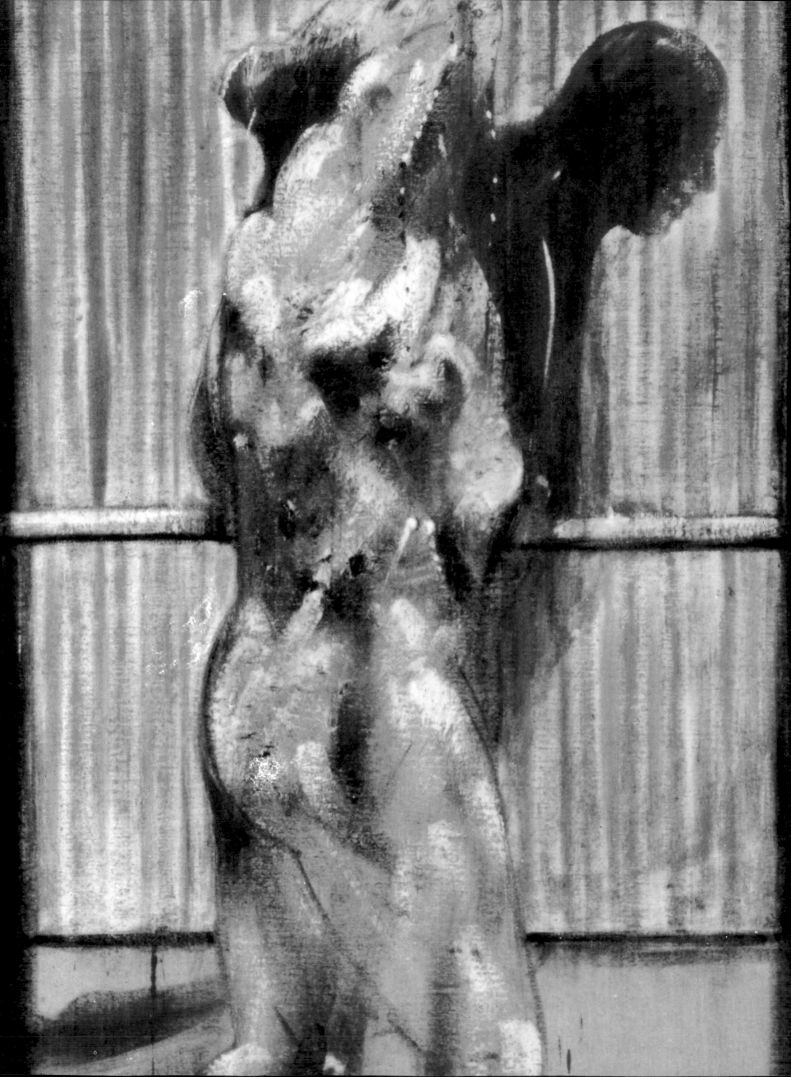

ALIST Bacon drew up in the early 1950s of pictures he was planning to paint was headed 'Images of the Human Body'. At that time the bodies were always male. Later they were sometimes female.

The male bodies tend to be paradigmatically male: heavily muscled, with broad shoulders and narrow hips. Even when their poses are manifestly based on photographs by Muybridge, their build is less slim and wiry than Muybridge's models tend to be, more massive: Muybridge's men could be welterweight boxers, Bacon's are like middleweights or cruiserweights. In works of the Forties and Fifties their musculature usually seems derived from Michelangelo; in works from the mid-Sixties on, from George Dyer's body as recorded in the photographs that Bacon commissioned from John Deakin. At the same time, the female bodies tend to be paradigmatically female: curvaceous and well-fleshed. They are generally based on the photographs of Henrietta Moraes also commissioned from Deakin. Bacon's lack of

Cat. 14
Henrietta Moraes, 1966
(detail)

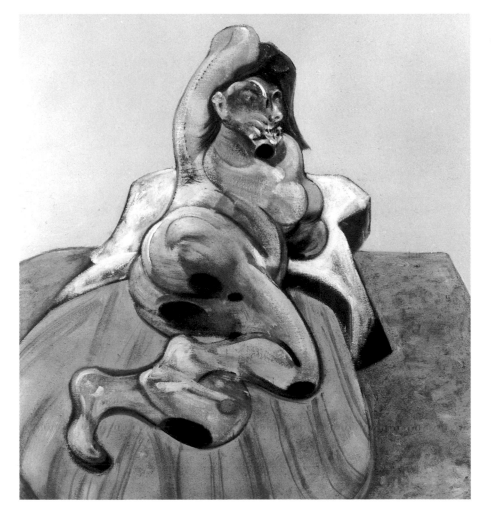

Cat. 4
Painting, 1950
(detail)

personal erotic interest in naked females did nothing to prevent these paintings from being as passionate as those of the male bodies that obsessed him.

A more dispassionate vision of the female body appears in the bare breasts of *Sphinx – Portrait of Muriel Belcher*, 1979; none of Deakin's known photographs of her could have provided a model. This image of the Sphinx is echoed in a more stylised form in *Oedipus and the Sphinx after Ingres*, 1983.

Besides these clearly male or female bodies, Bacon also painted a number of nudes whose gender seems uncertain. There are six very similar extant images dating from around 1960 – four in oils, two in gouache – of a figure lying upside down on a sofa: in every case the body is androgynous, whether it has a penis or not; indeed, while the three oils dated 1959 are entitled *Lying Figure* or *Reclining Figure*, the one dated 1961 is called *Reclining Woman*. All of them have a build which suggests that they could have been based on the artist's body. It was, in fact, with these images in mind that in my 1966 television interview with Bacon I asked him whether his figures were ever based on his own body; this he firmly denied. The exchange is not preserved

Fig. 4
Sphinx – Portrait of Muriel Belcher, 1979
(detail)
oil on canvas
198 x 147.5 cm
National Museum of Modern Art, Tokyo

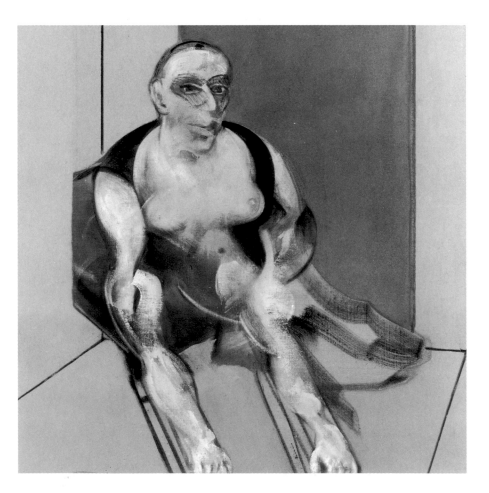

Fig. 5
Lying Figure No.1, 1959
(detail)
oil on canvas
197 x 140.5 cm
Leicester City
Museums Service

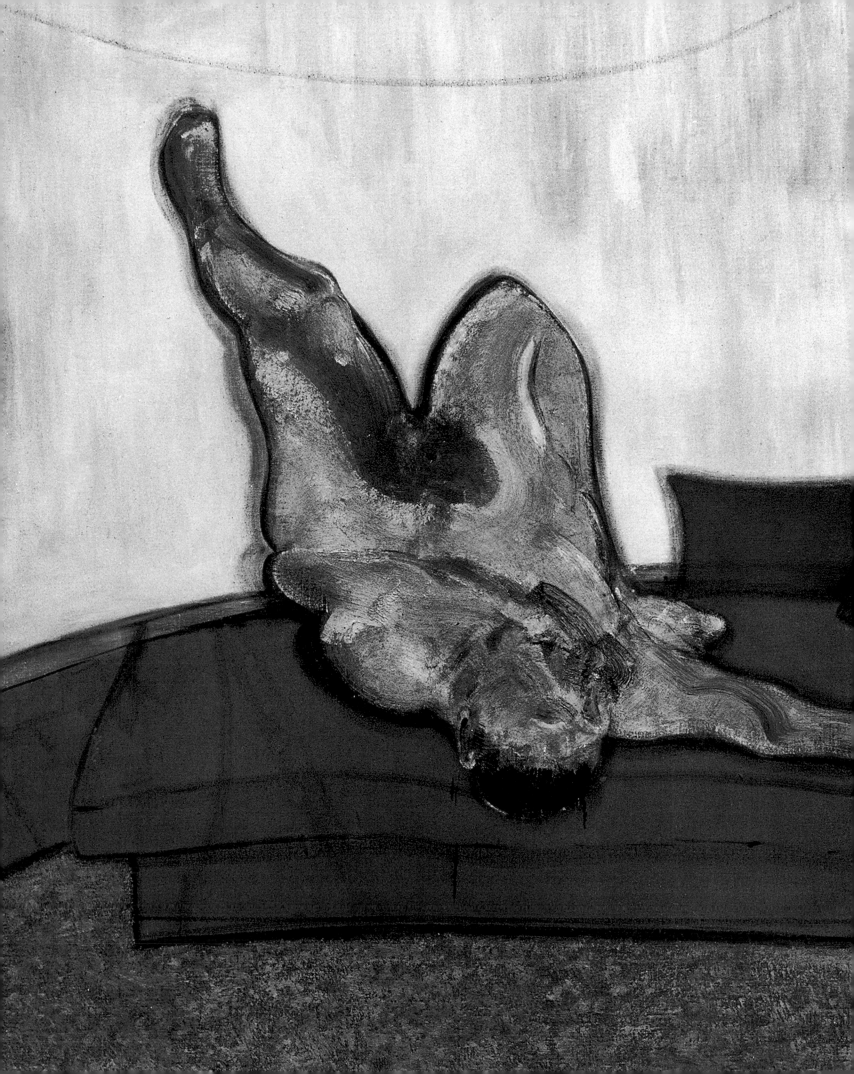

in the published version of the interview, only in the film, which shows that while making his denial Bacon was repeatedly running his right thumb up and down the inside of his bare left forearm. However, *Sleeping Figure*, 1974, is a sort of self-portrait and is not at all androgynous.

In the *Sweeney Agonistes* triptych of 1967 all four reclining figures are androgynous and two of them are almost certainly women. In *Triptych – Studies of the Human Body*, 1970, the figure in the left-hand panel is androgynous, while the other two are undoubtedly women, and women who do not resemble the images of Henrietta. The face of the one on the right looks remarkably like Bacon's face. Furthermore, the eyes seem to be blind. An image comes to mind – that of Tiresias. (I have no idea whether Bacon consciously saw this figure either as an image of Tiresias or as an image of himself.)

In *The Waste Land*, that poem which Bacon always said was 'full of echoes', none of the voices that emerge from the murmur, the prattle, the lamentations of the rapidly changing scenes is more resonant than that of Tiresias – 'I Tiresias, though blind, throbbing between two lives, / Old man with wrinkled female breasts...' – who plays the role of detached observer of a sexual encounter which leaves the woman 'glad it's over': 'I Tiresias, old man with wrinkled dugs / Perceived the scene, and foretold the rest'. And Eliot, in his notes to the poem, says: 'Tiresias, although a mere spectator and not indeed a "character", is yet the most important personage in the poem, uniting all the rest... the two sexes meet in Tiresias. What Tiresias sees, in fact, is the substance of the poem.'

The two sexes met in Francis Bacon, more than in any other human being I have encountered. At moments he was one of the most feminine of men, at others one of the most masculine. He would switch between these roles as suddenly and as unpredictably as the switching of a light. That duality did more than anything perhaps to make his presence so famously seductive and compelling and to make him so peculiarly wise and realistic in his observation of life.

'And I Tiresias have foresuffered all
Enacted on this same divan or bed;
I who have sat by Thebes below the wall
And walked among the lowest of the dead.'

Cat. 17
Triptych – Studies of the Human Body, 1970
(detail from right-hand panel)

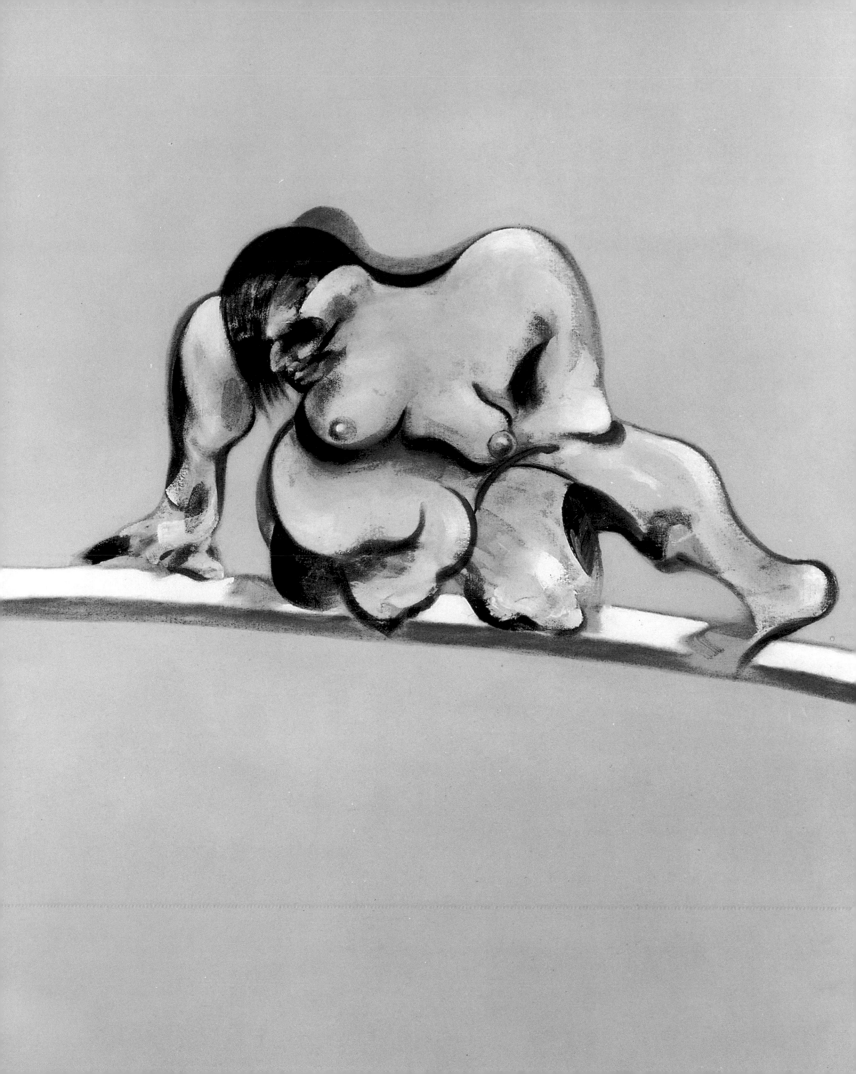

PLATES

Cat. 1
Untitled, 1943 or 1944
(variant of the right-hand panel of the triptych
Three Studies for Figures at the Base of a Crucifixion, 1944
in the Tate Gallery)
94 X 74 cm

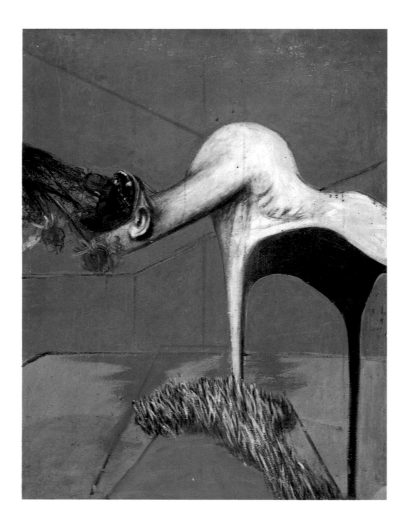

Cat. 2
Figure Study II, 1945–46
145 X 128.5 cm

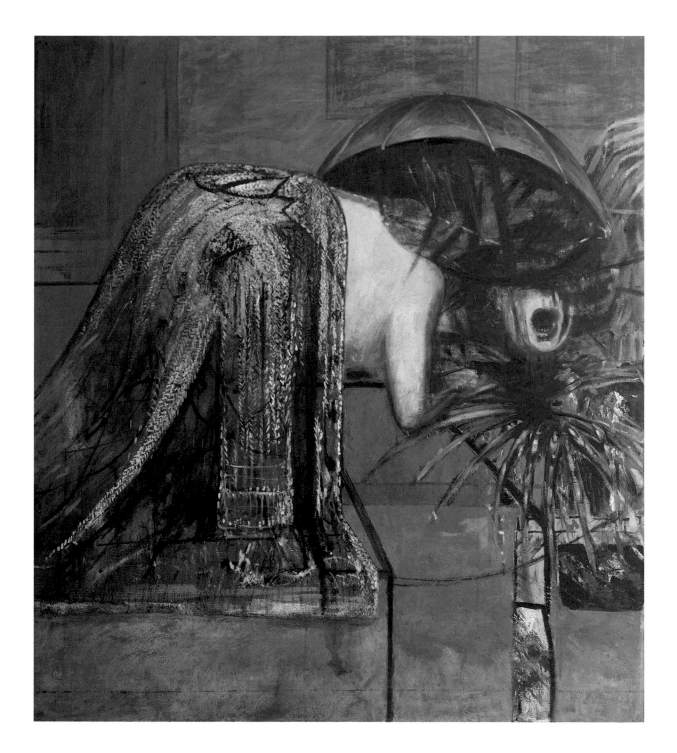

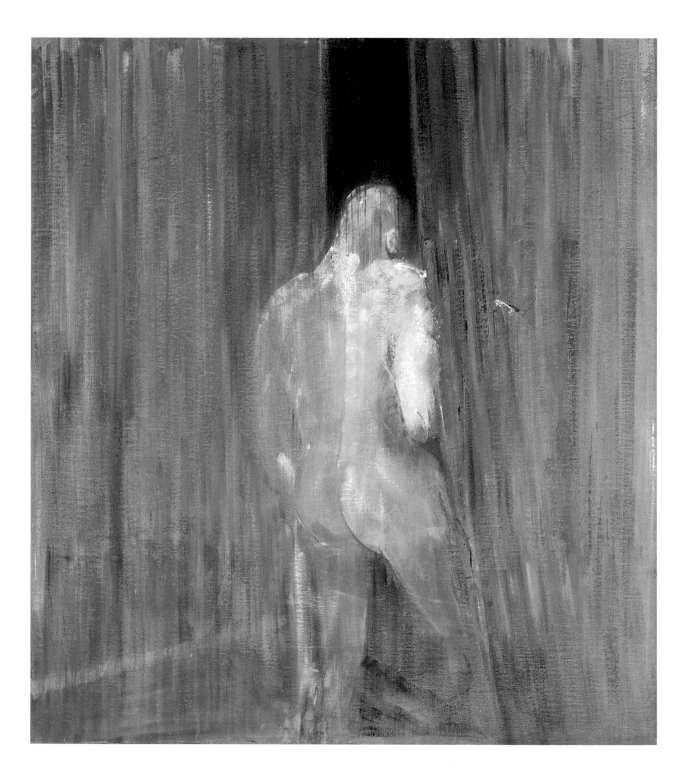

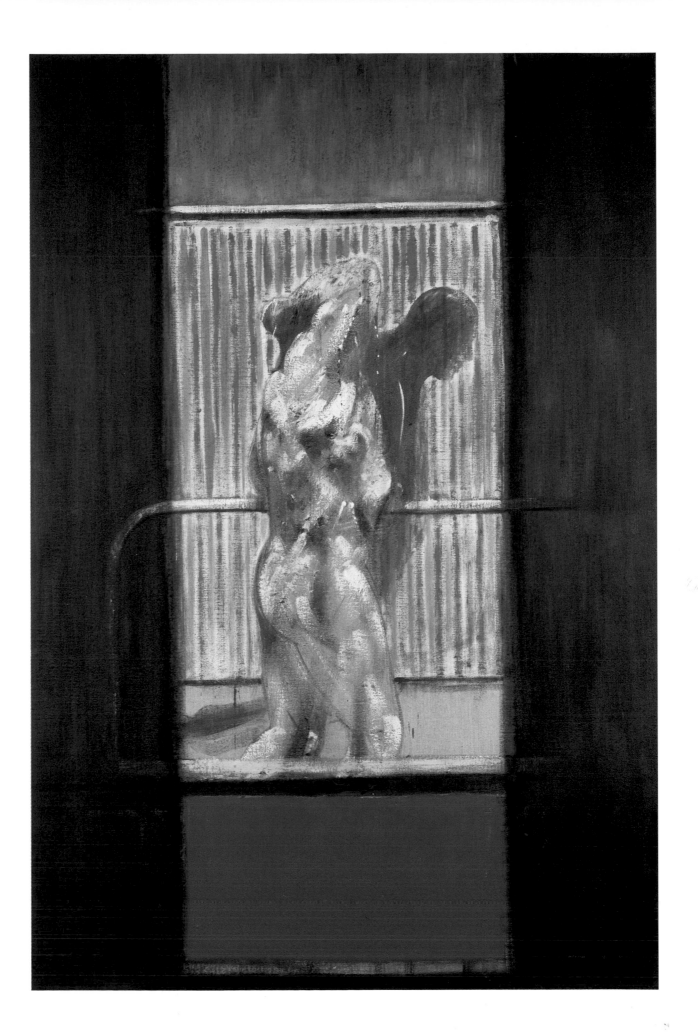

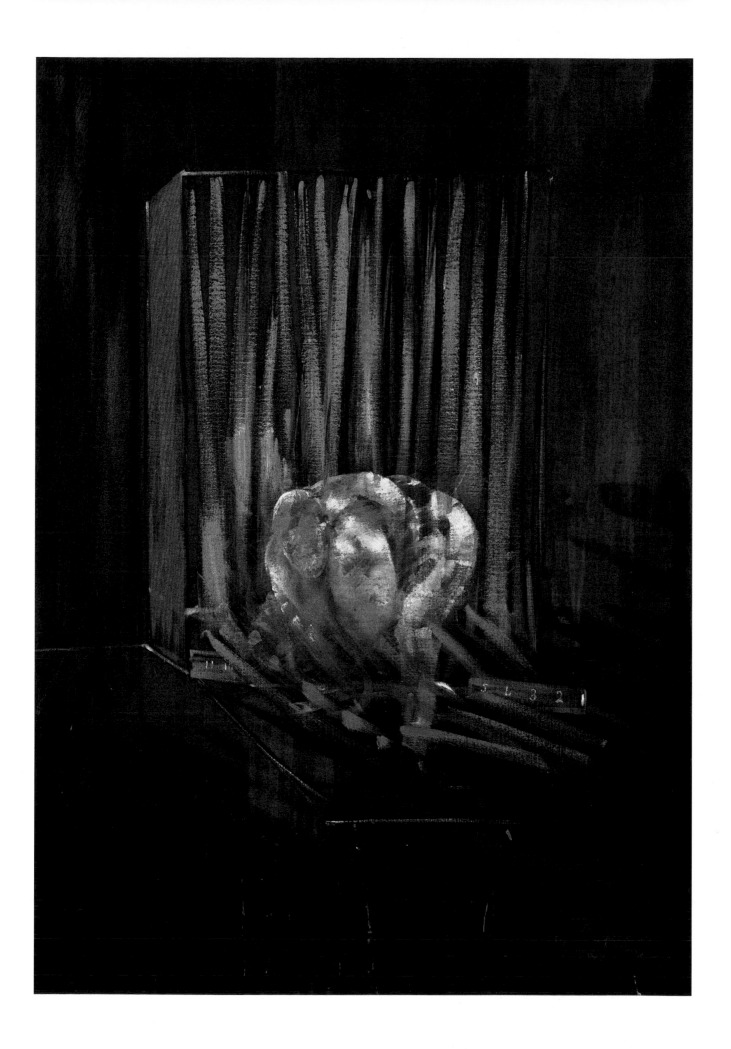

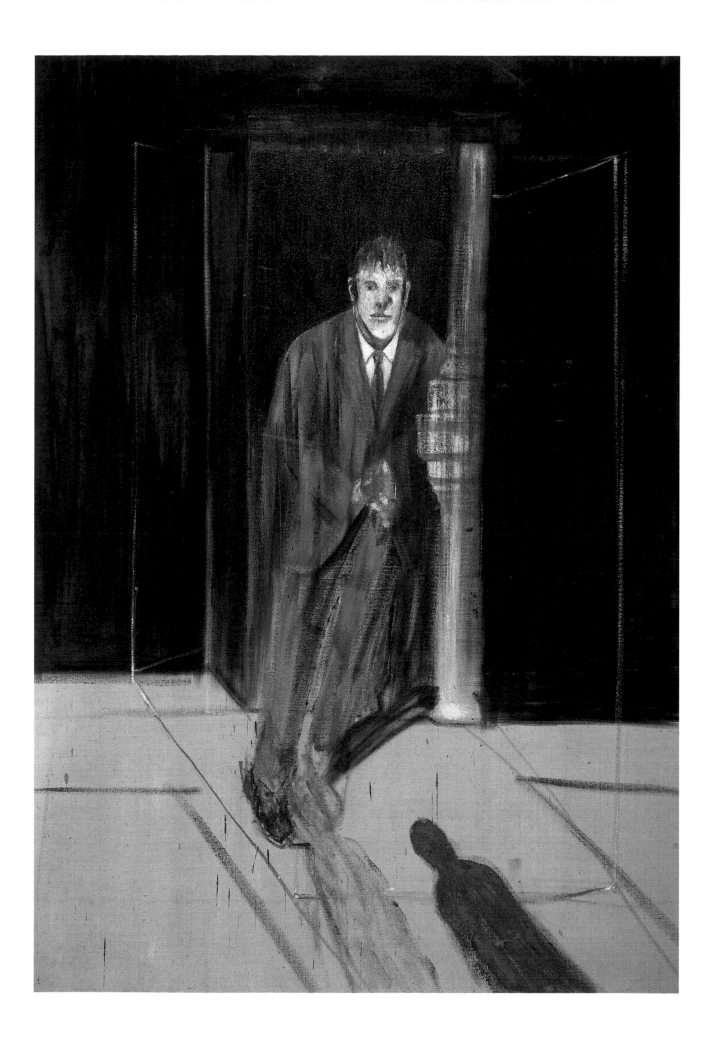

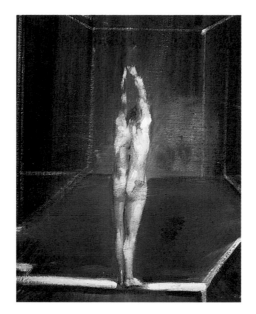

Cat. 8
Study for Figure II, 1953/55
198 x 137 cm

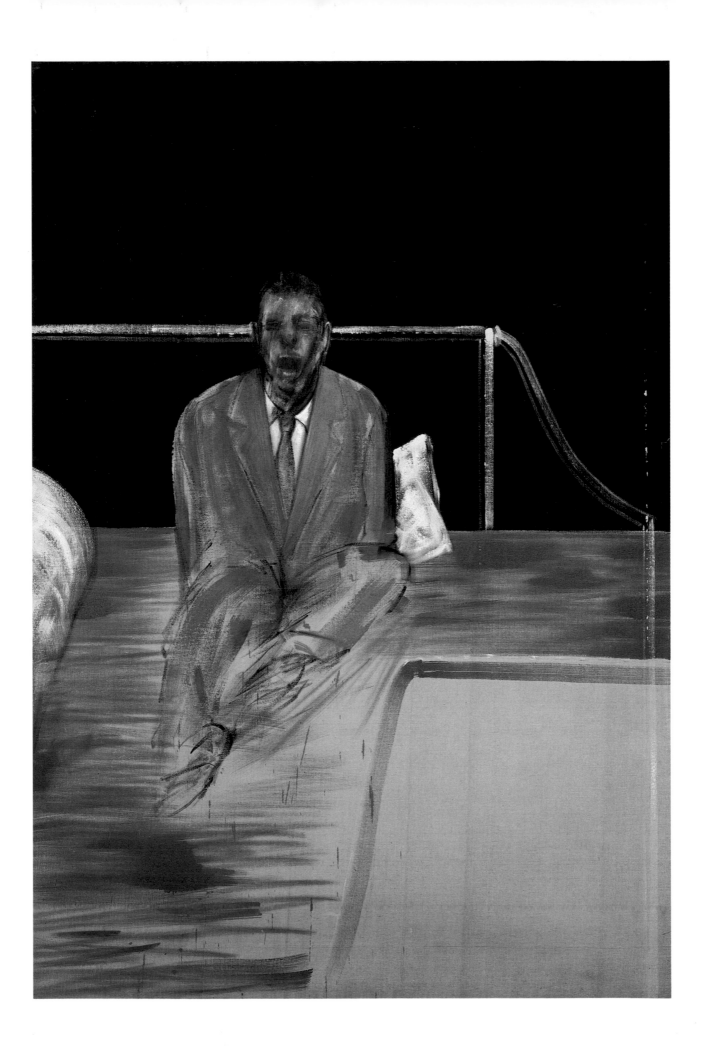

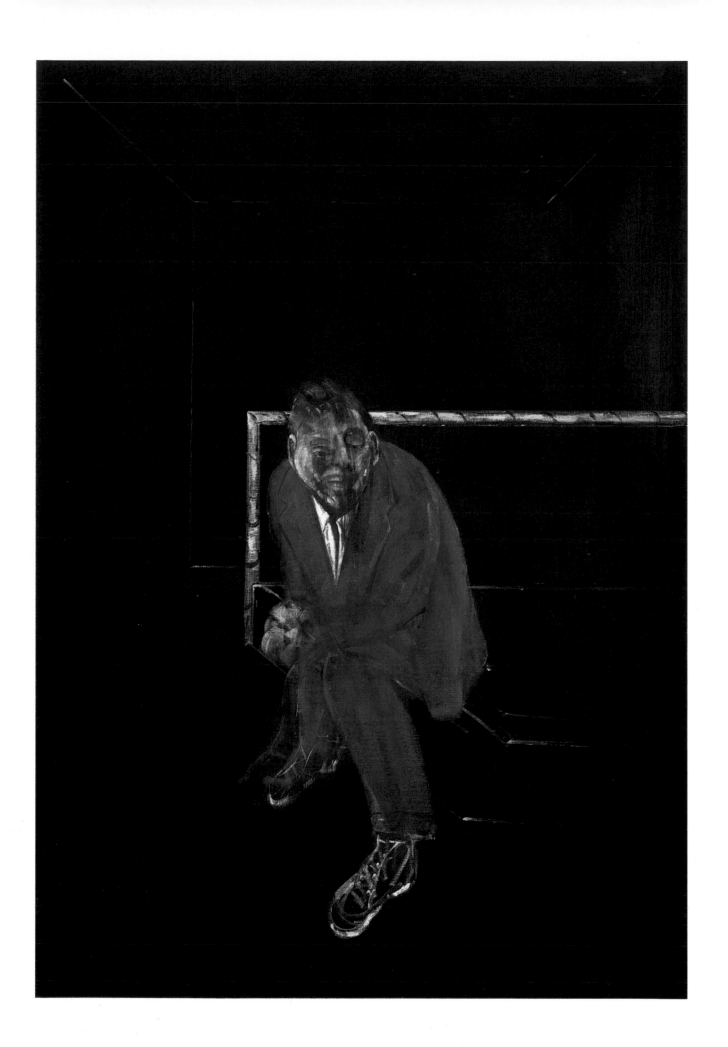

Cat. 10
Study for a Pope IV, 1961
152 X 119 cm

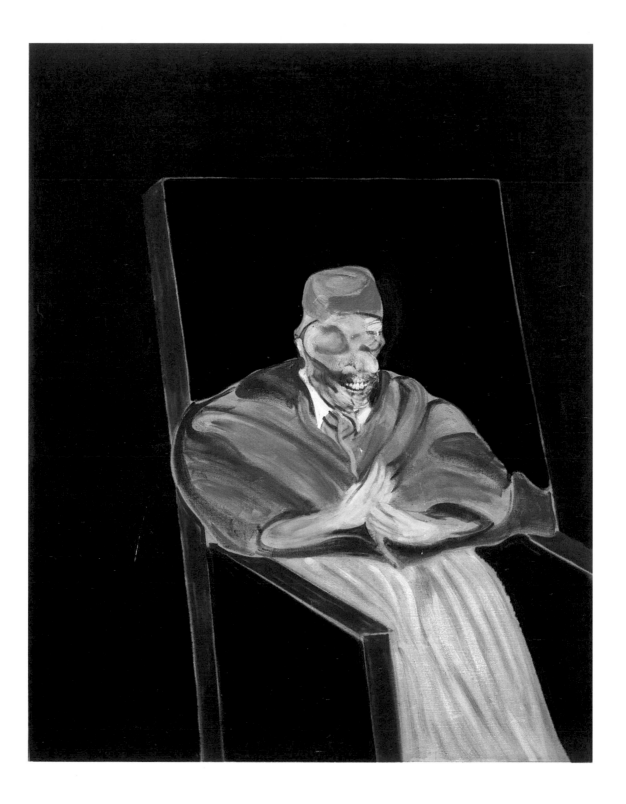

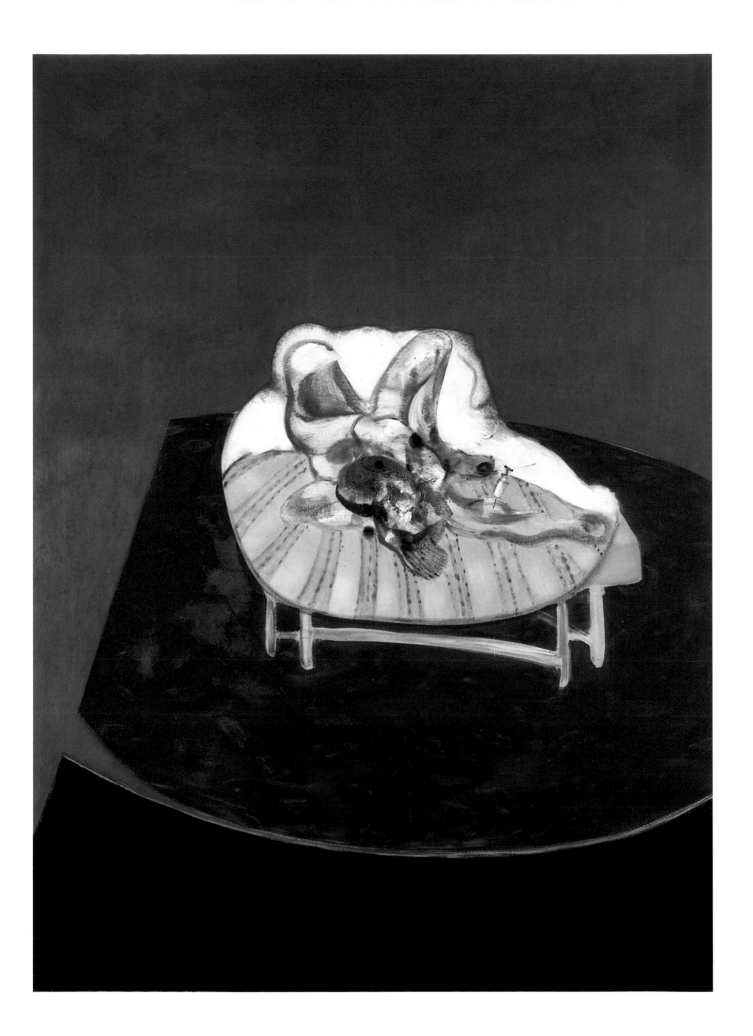

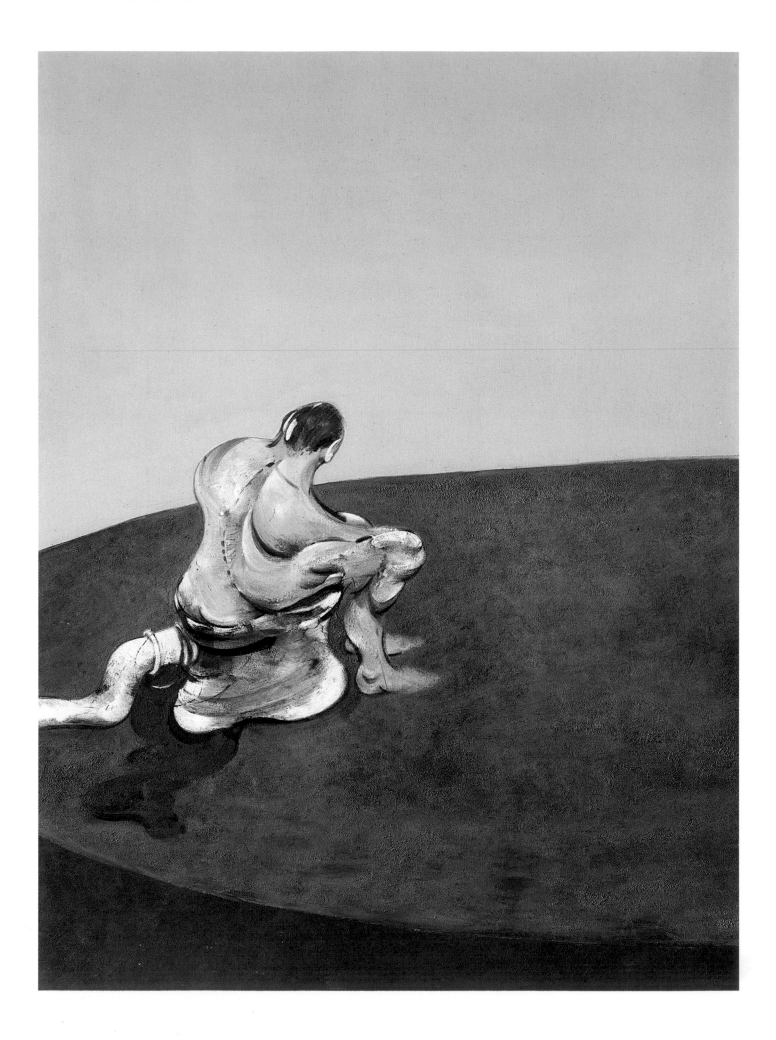

Cat. 12
Three Figures in a Room, 1964
each panel 198 x 147 cm

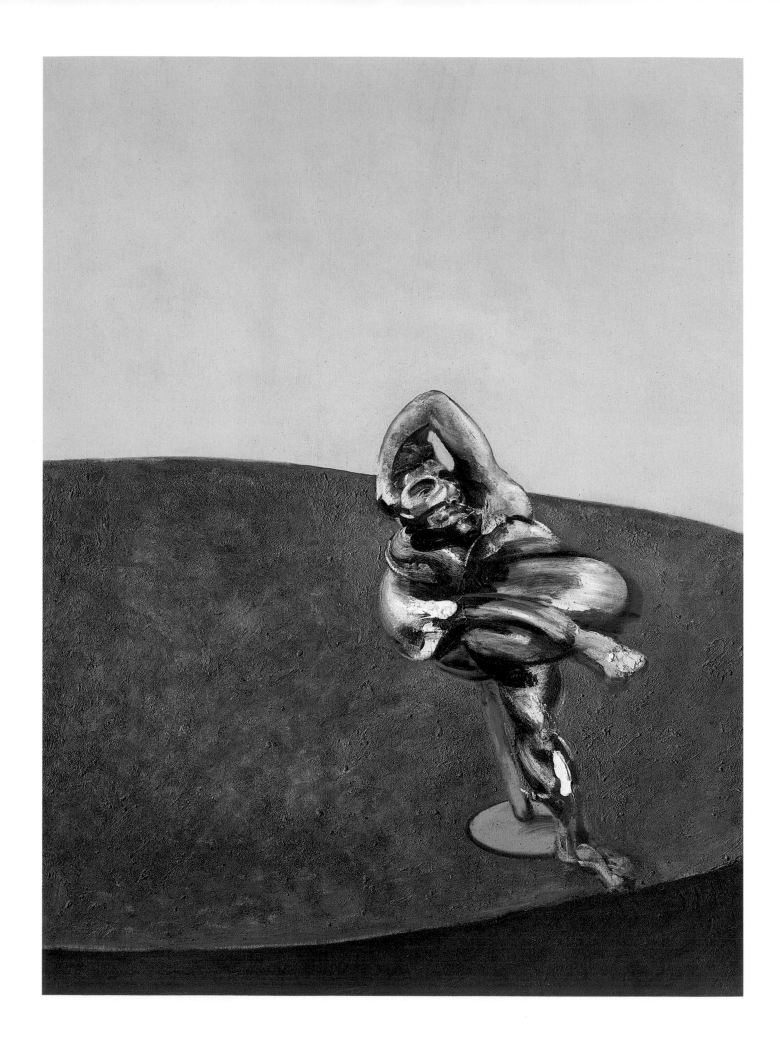

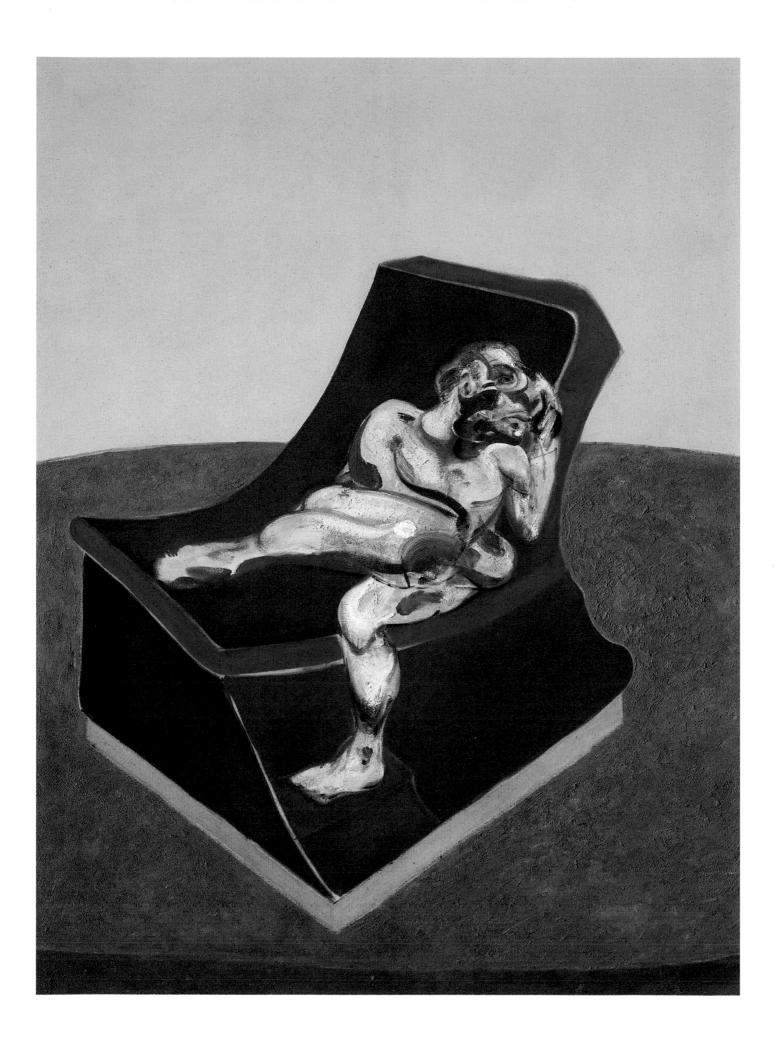

Cat. 13
Portrait of Lucian Freud (on orange couch), 1965
156 x 139 cm

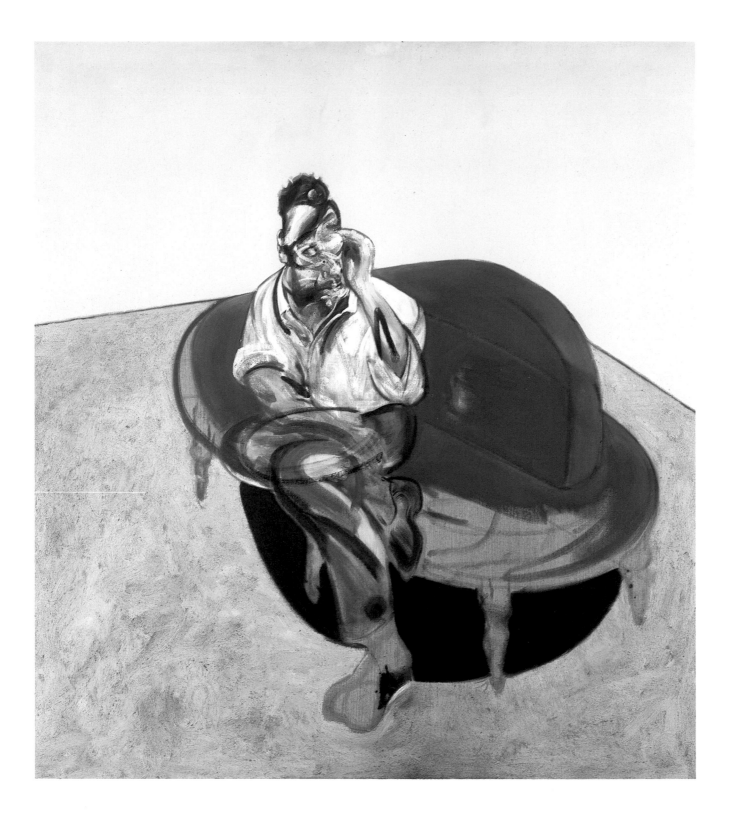

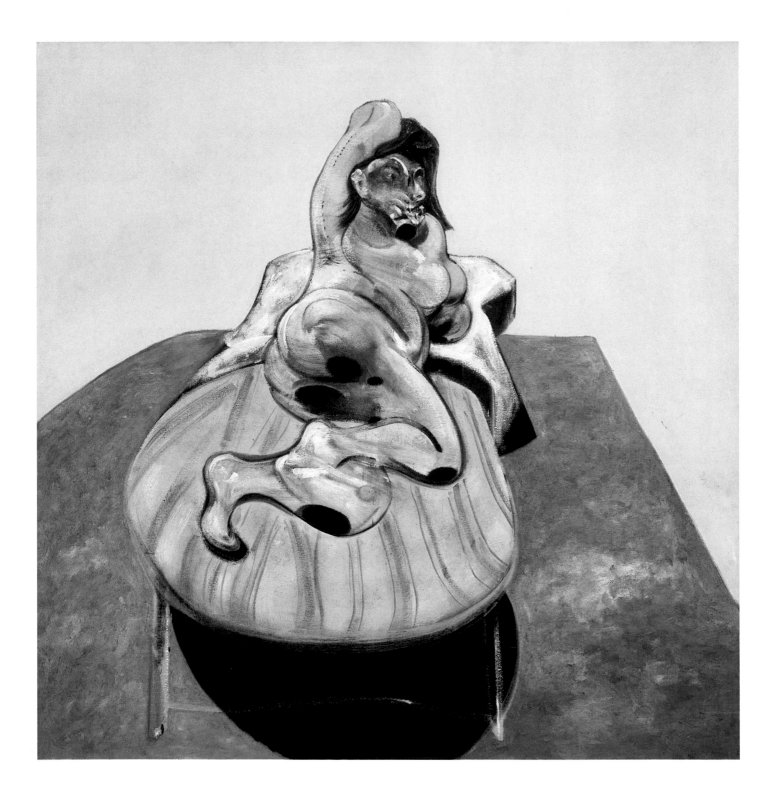

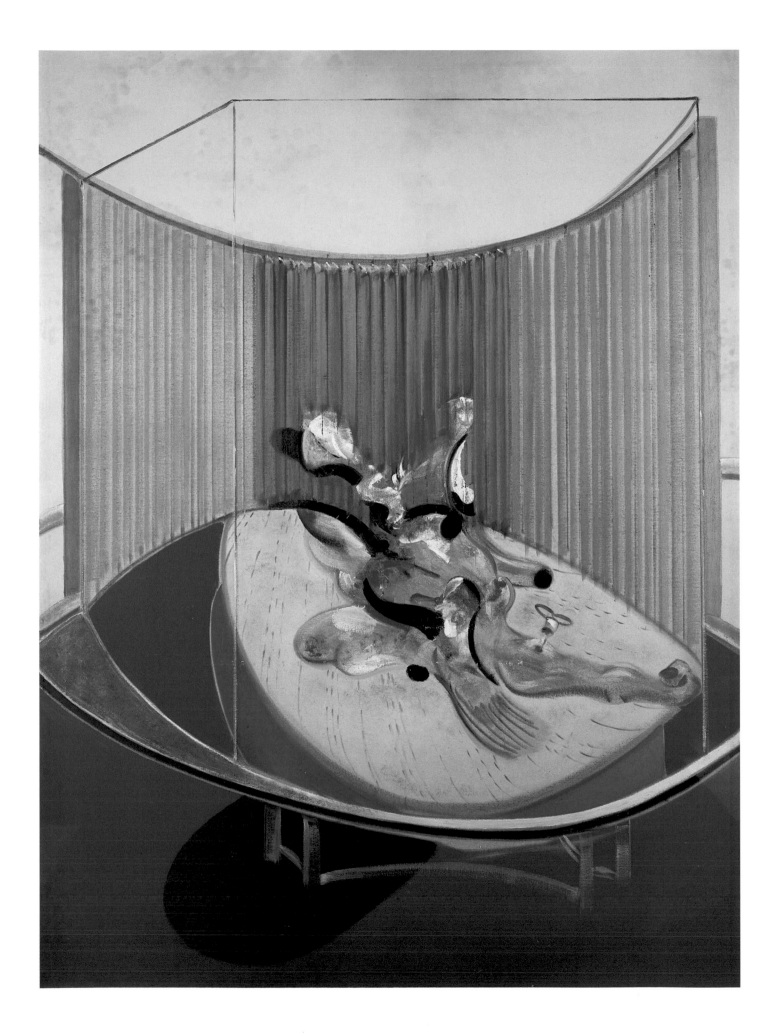

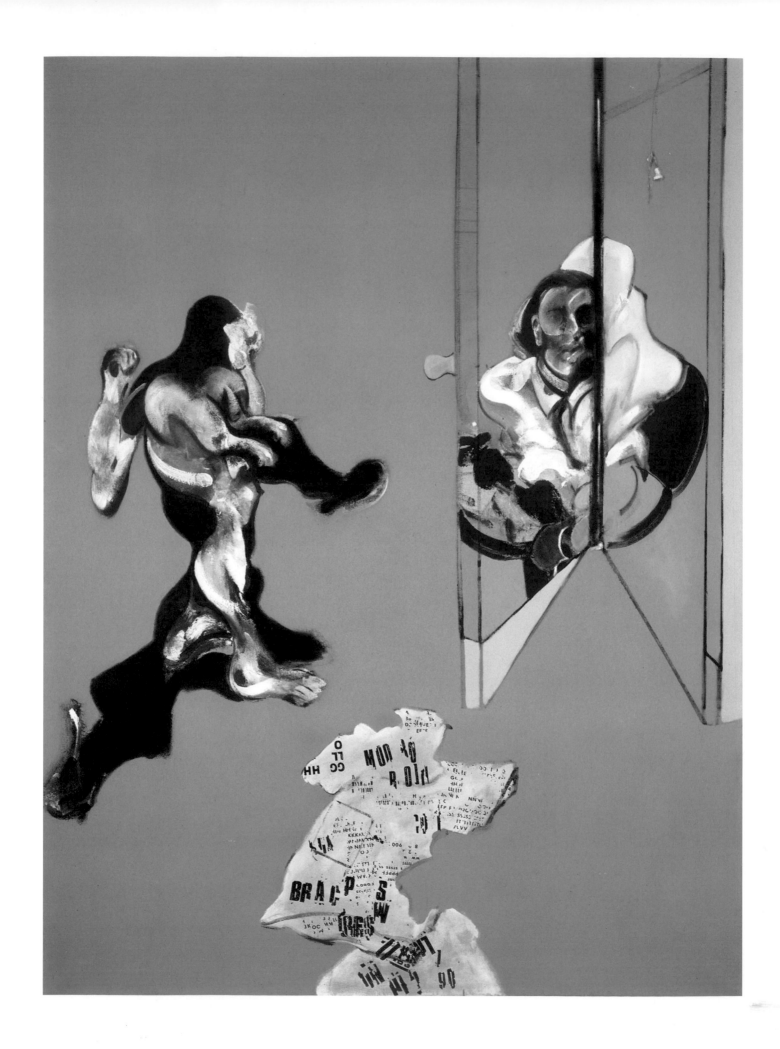

Cat. 16
Triptych – Studies from the Human Body, 1970
each panel 198 x 147.5 cm

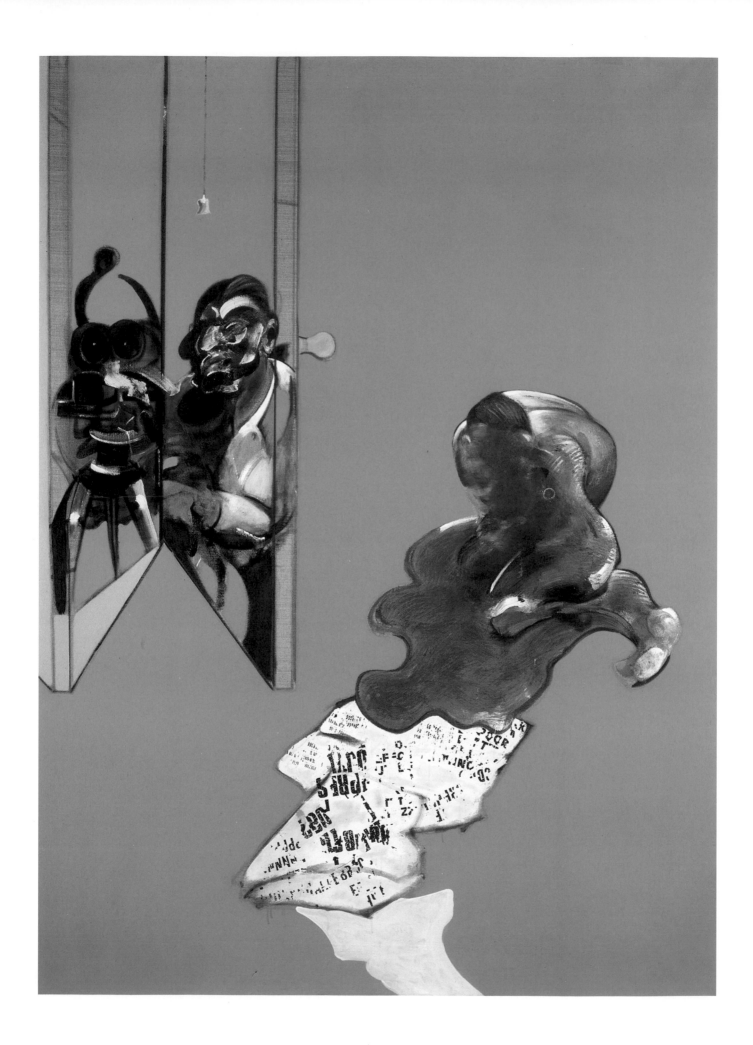

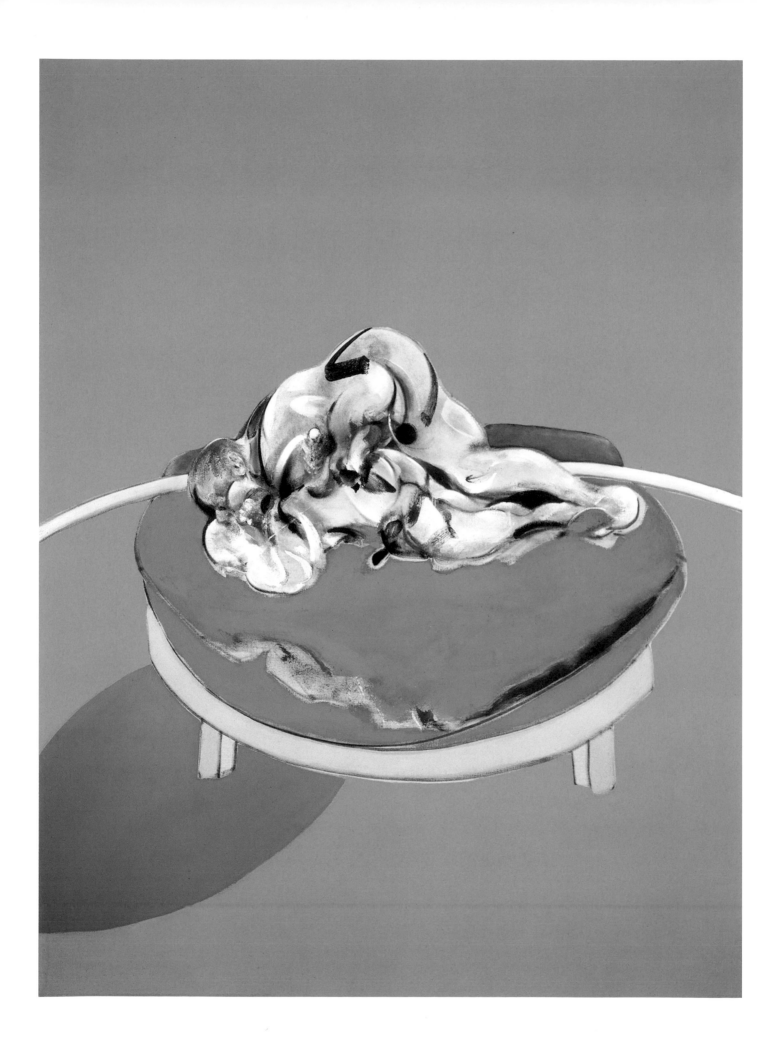

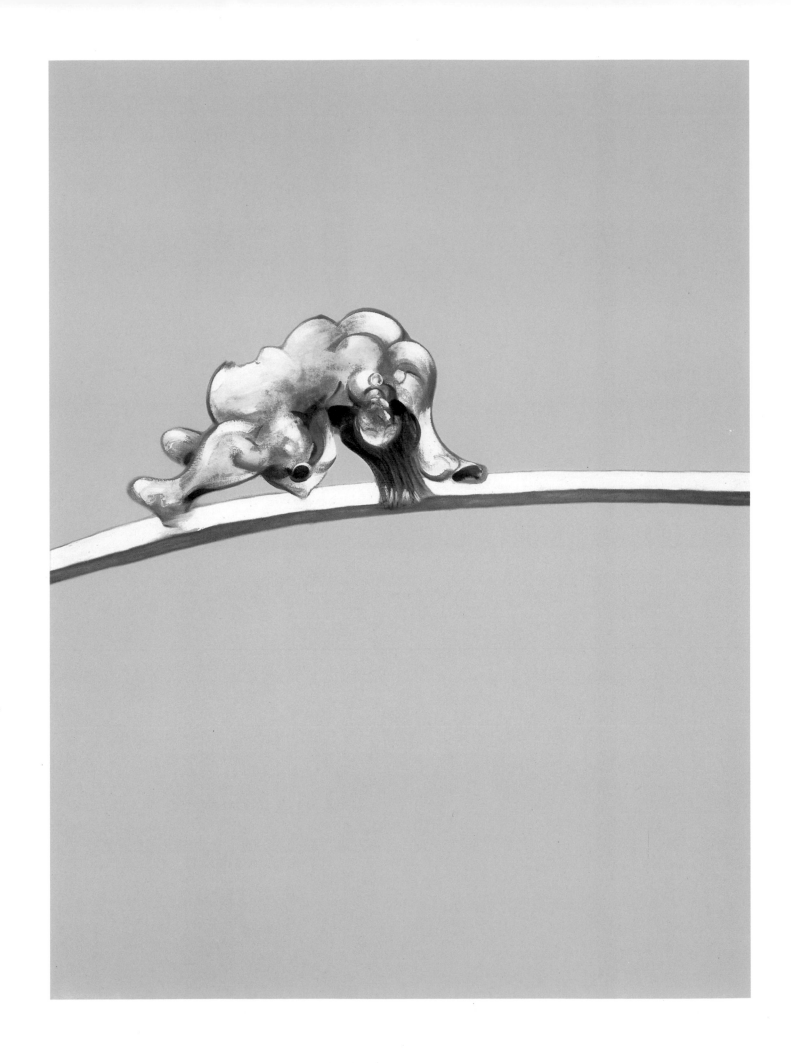

Cat. 17
Triptych — Studies of the Human Body, 1970
each panel 198 x 147.5 cm

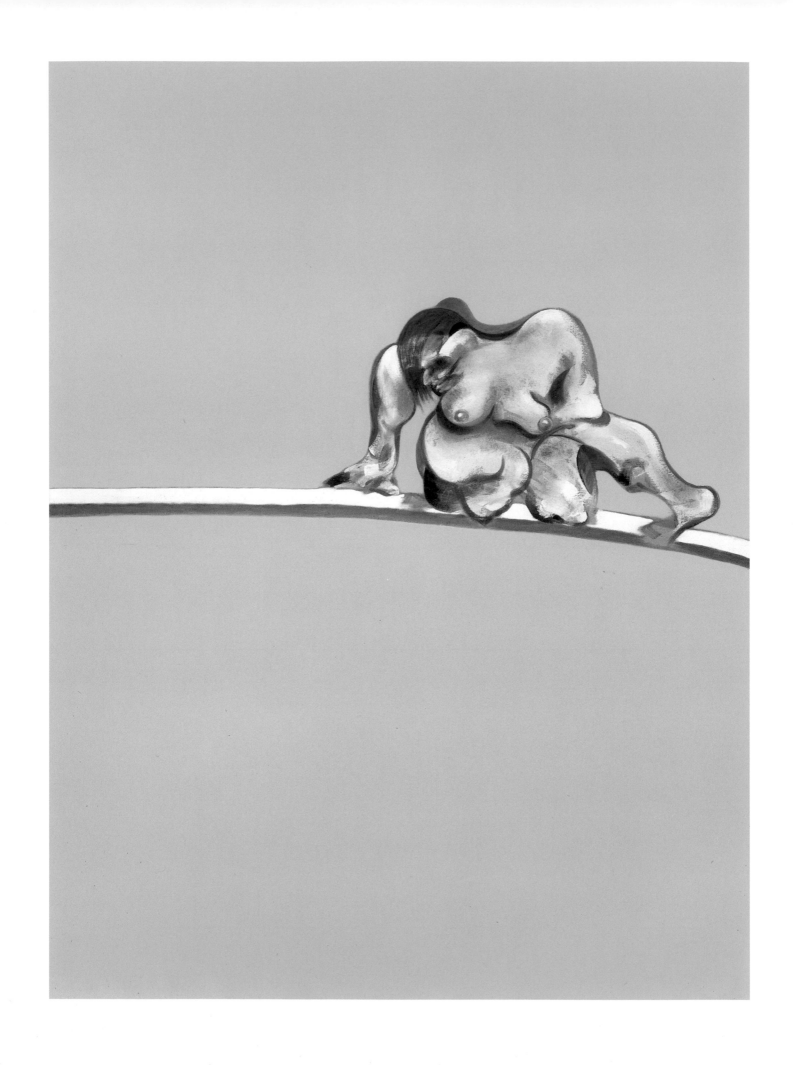

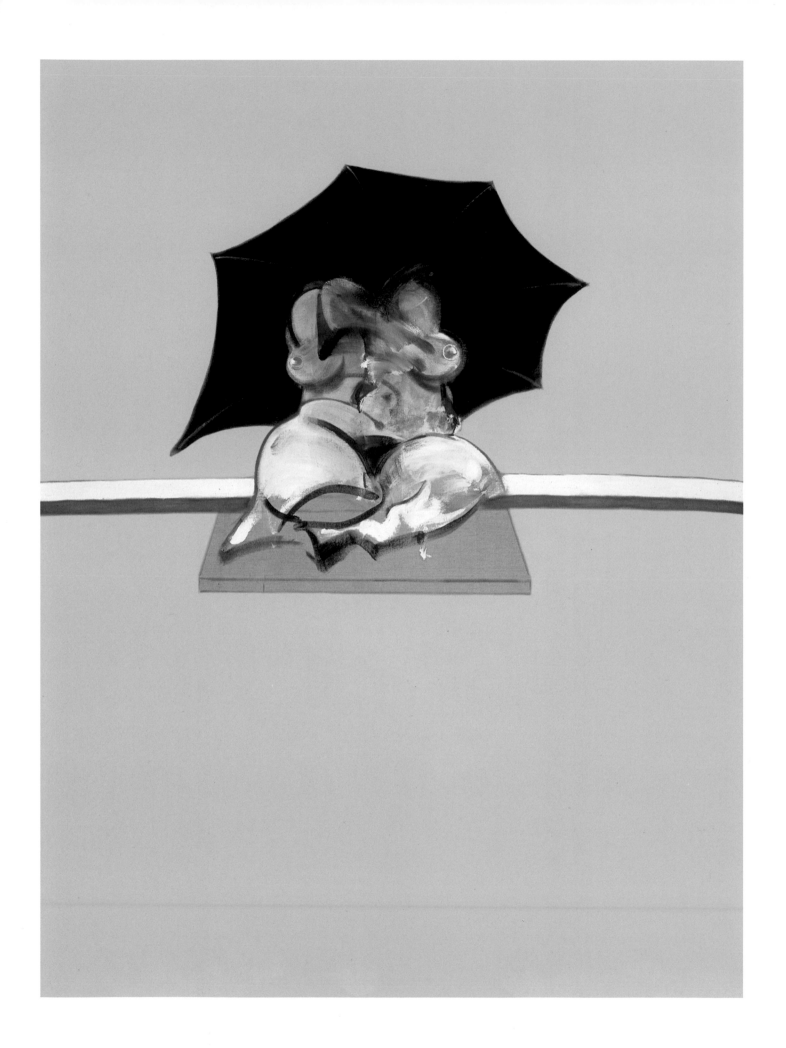

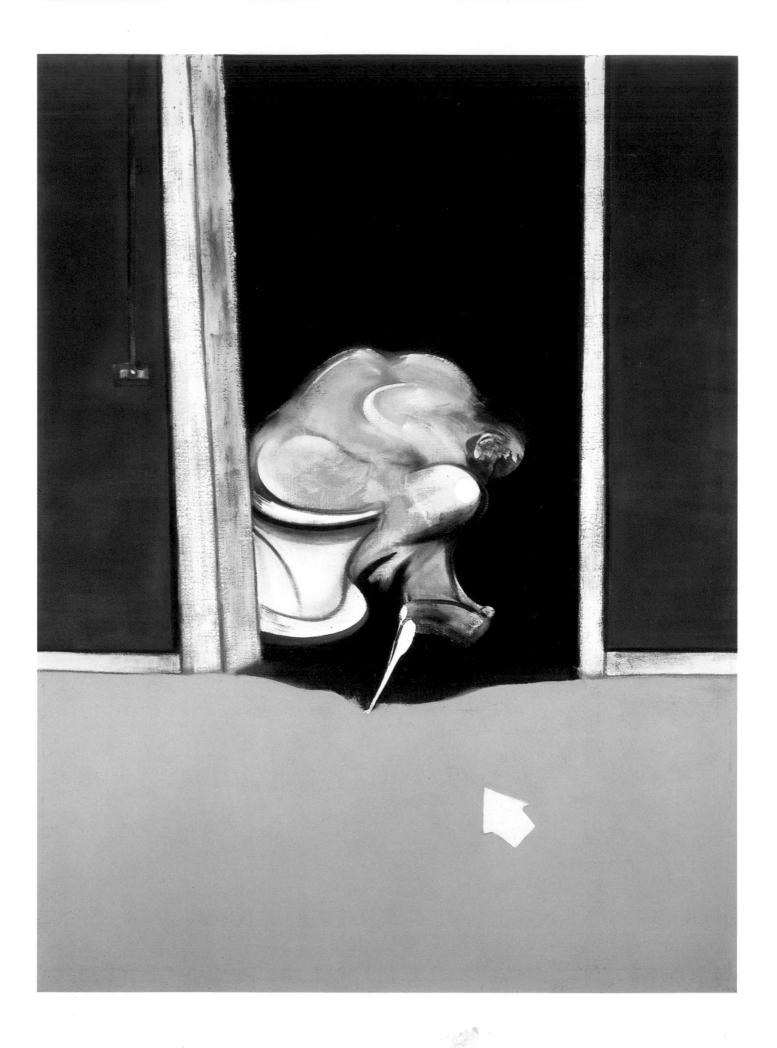

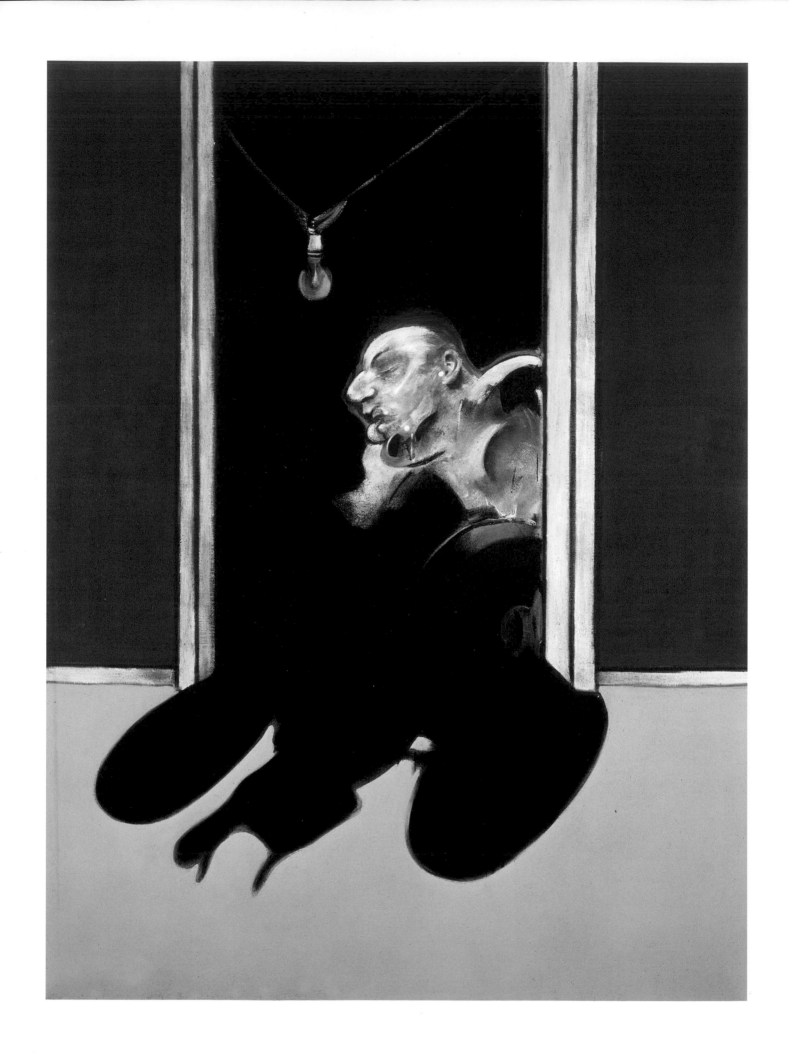

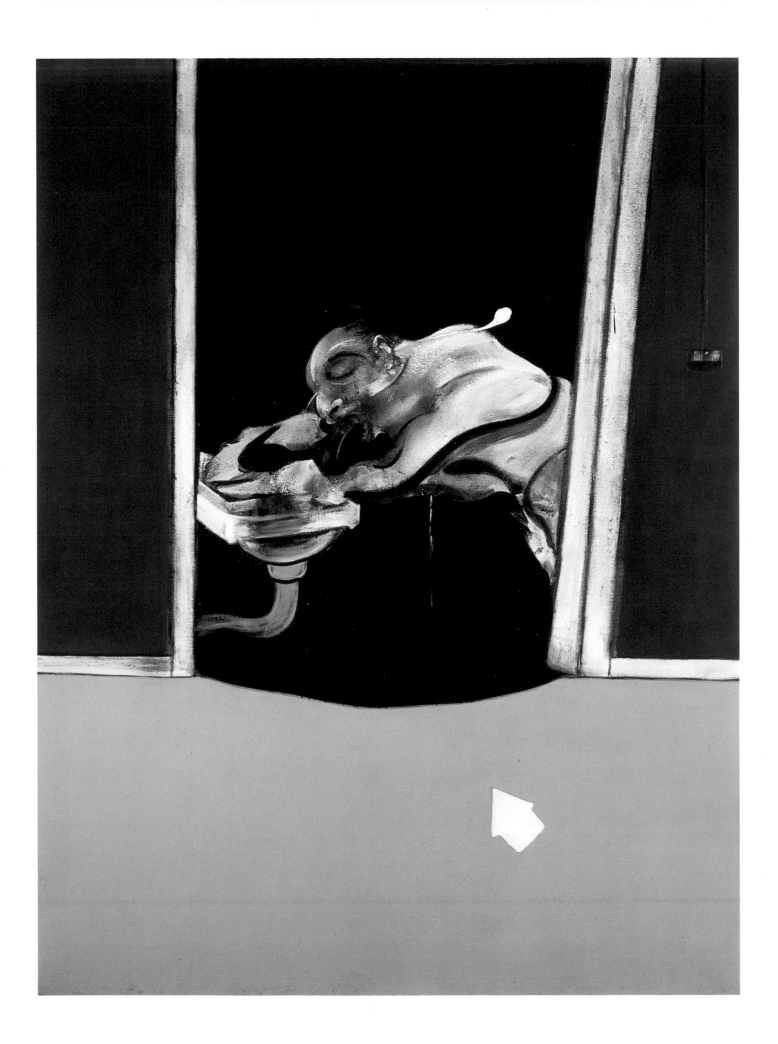

Cat. 18
Triptych May–June 1973, 1973
each panel 198 x 147.5 cm

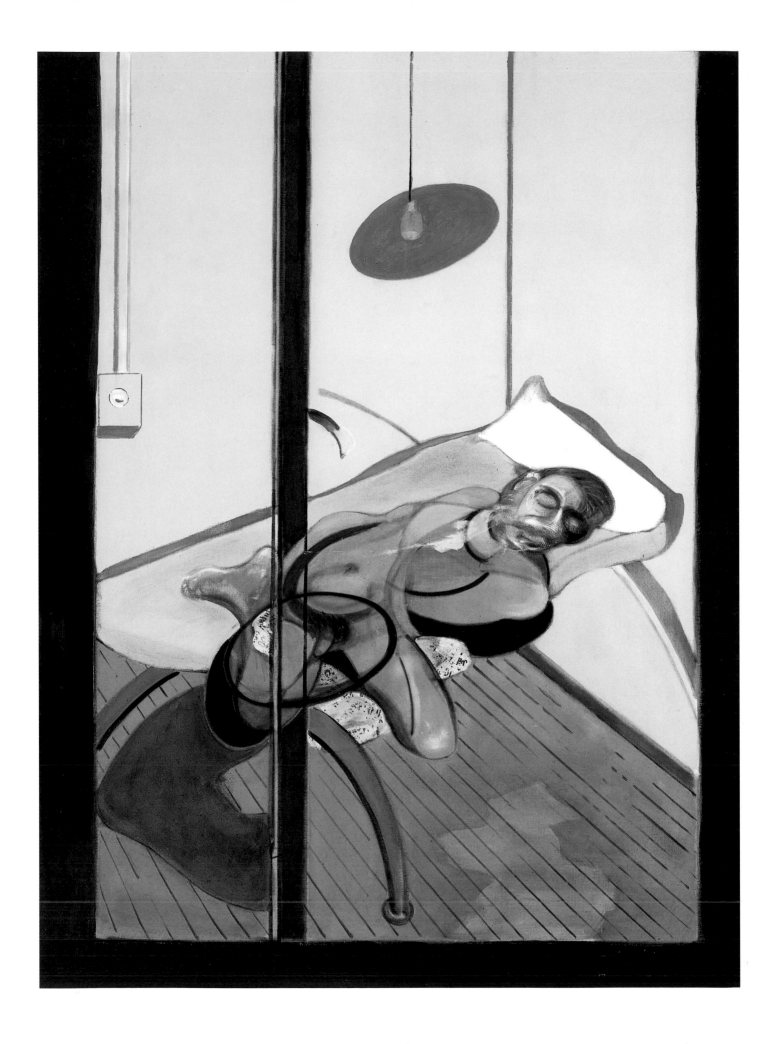

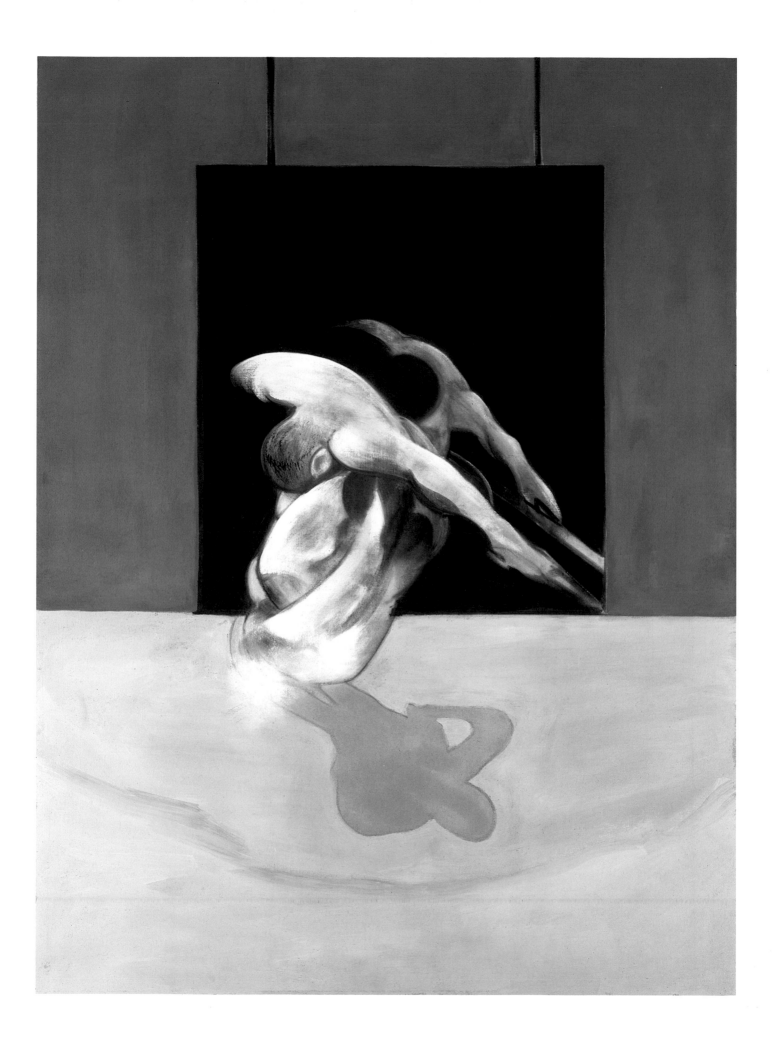

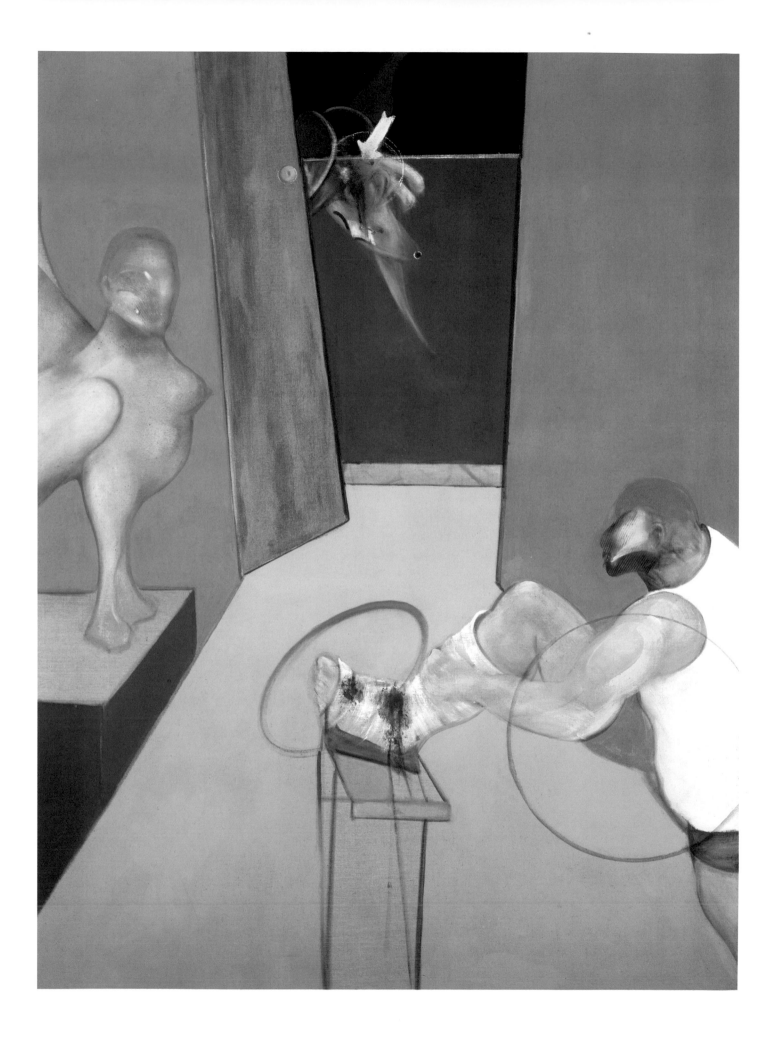

Cat. 22
Figure in Movement, 1985
198 x 147.5 cm

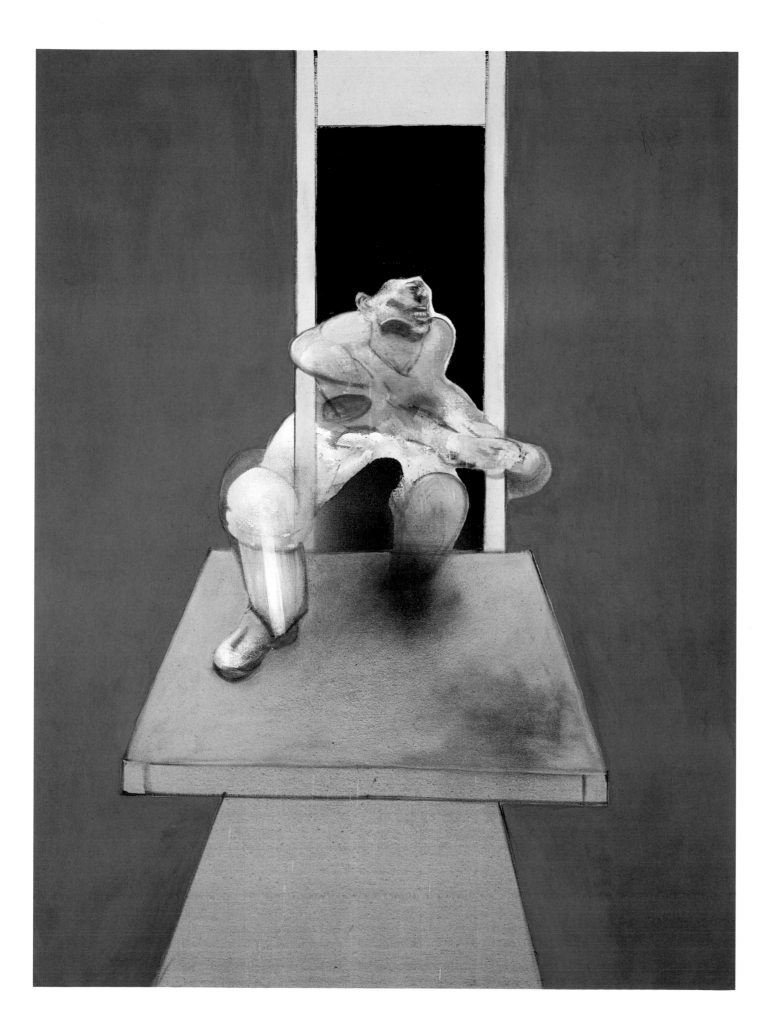

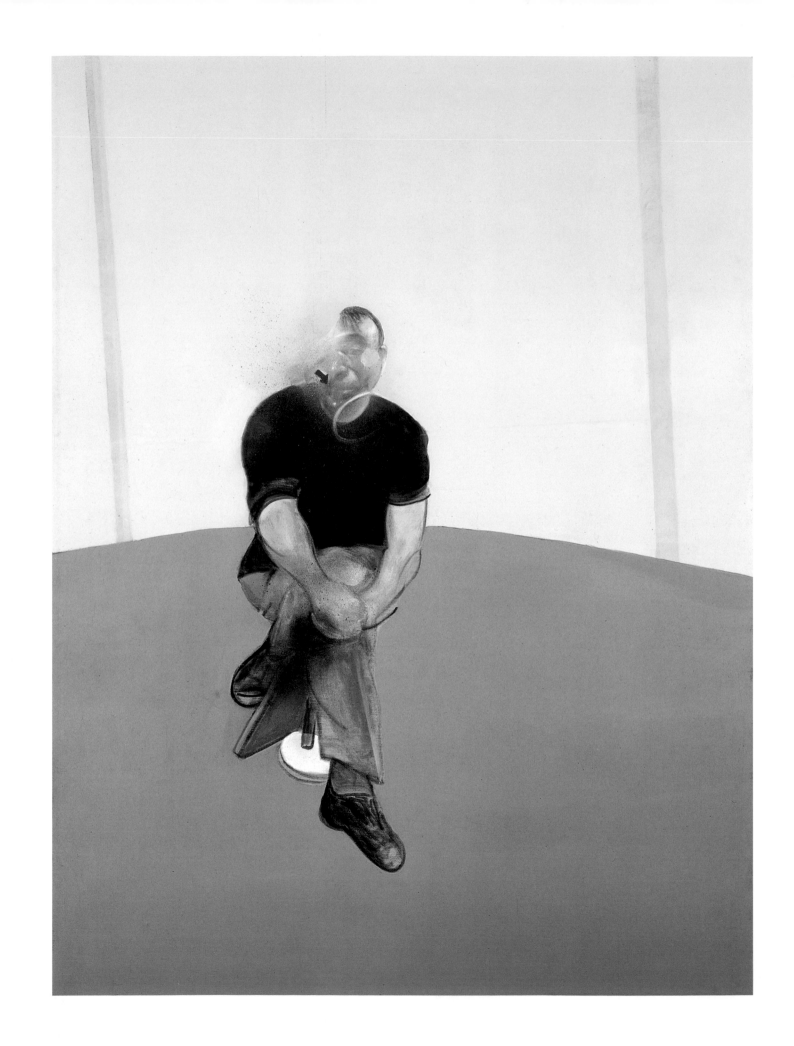

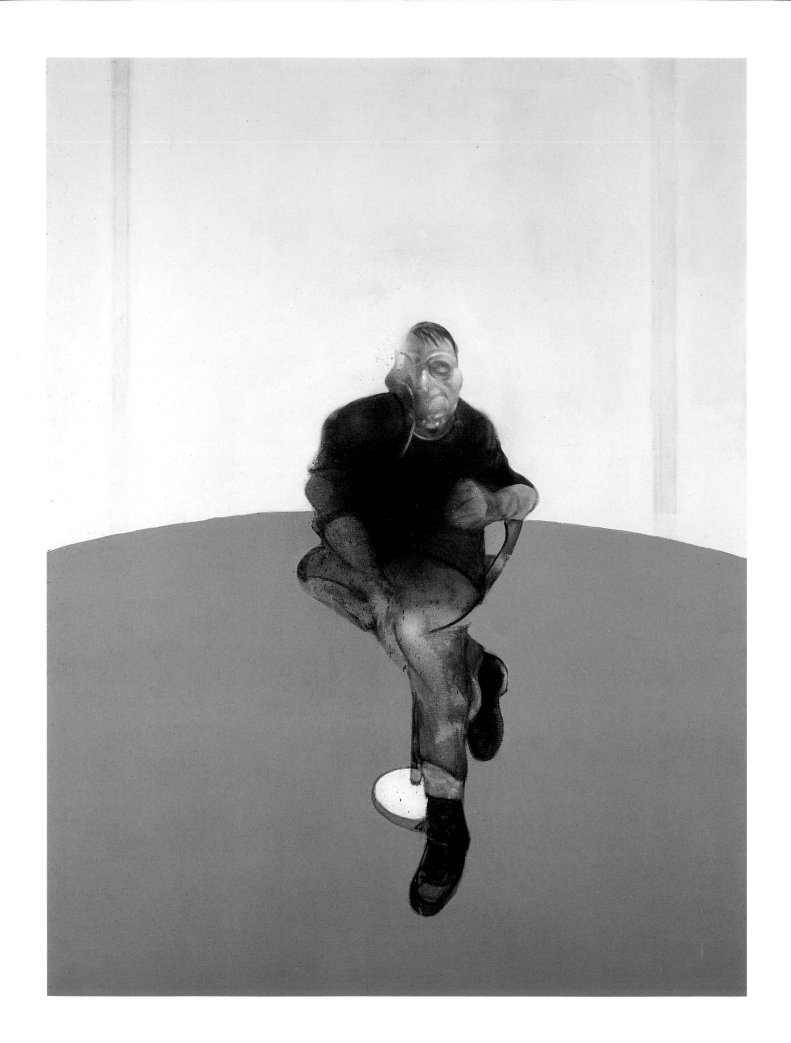

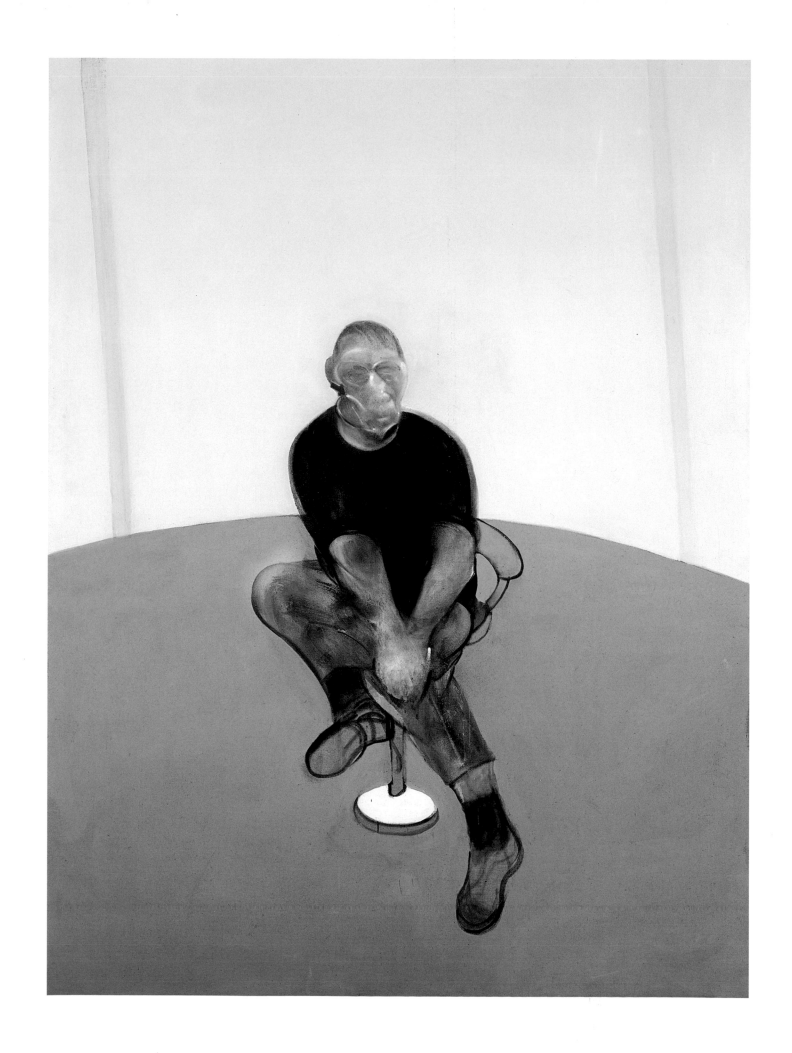

Cat. 23
Study for Self-Portrait – Tripych 1985–86, 1985–86
each panel 198 x 147.5 cm

BIOGRAPHICAL NOTE

SELECT BIBLIOGRAPHY

LIST OF WORKS

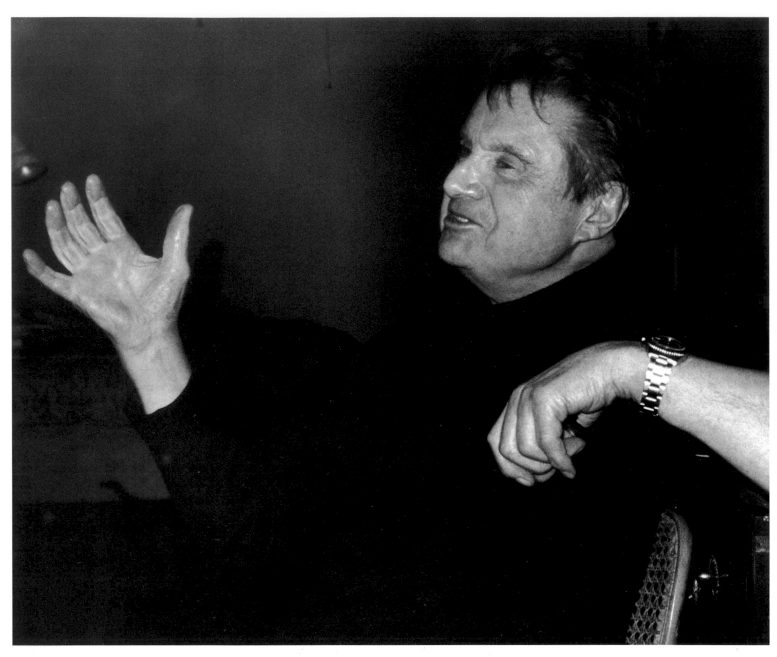

Francis Bacon in his studio in 1984
John Edwards

BIOGRAPHICAL NOTE

Francis Bacon was born on 28 October 1909 in a Dublin nursing-home, the second of five children of English parents living at Cannycourt House in County Kildare, Anthony Edward Mortimer Bacon (1870-1940) and Christina Winifred Loxley Bacon (1884-1971). Eddy Bacon was a retired army captain who trained race-horses unsuccessfully. He was himself the son of an army captain who was the son of General Anthony Bacon; the family were collateral descendants of the Elizabethan Francis Bacon. Winnie Bacon, née Firth, came from the Sheffield family of cutlery manufacturers.

From an early age and throughout his life Bacon suffered from asthma.

During the War Eddy Bacon had a job at the War Office and the family lived mainly in London. After it ended they lived in various country houses in both England and Ireland; Bacon enjoyed getting away from his parents and staying with his maternal grandmother in County Leix. From the autumn of 1924 to the spring of 1926 he boarded at Dean Close School, Cheltenham.

In 1926 he left home, initially travelling with a friend of his father's with whom he spent several months in Berlin. He went on to Paris, where he started making drawings and watercolours after seeing an exhibition of Picasso drawings in the summer of 1927. In order to get some mastery of French he spent three months with a family near Chantilly.

Back in London, he lived and worked from 1929 to 1932 in a converted garage at 17 Queensberry Mews West, South Kensington, designing modernist furniture and carpets and doing some painting. His decorative art soon brought both publicity – a feature about him in *The Studio* in 1930 – and a clientele that included Patrick White, Sydney Courtauld Butler and Eric Hall. He became involved in an amorous relationship with Hall that was to last at least fifteen years. He also acquired a sort of mentor in the Australian post-cubist painter, Roy de Maistre, born 1894, and in November 1930 shared an exhibition in his studio with de Maistre and Jean Shepeard. After this he turned increasingly from decorative arts to painting, supporting himself by doing various odd jobs, mostly in domestic service.

He shared his living quarters with his old nanny, Jessie Lightfoot, continuing to do so for most of the time until her death at eighty in 1951; Eric Hall, who had a family, was part of the ménage intermittently. In 1932 Bacon moved to Fulham Road and in 1933 to 71 Royal Hospital Road, Chelsea, where he produced his first significant paintings, notably the *Crucifixion* of 1933, heavily influenced by Picasso treatments of that subject, which was exhibited at the Mayor Gallery, purchased by Sir Michael Sadler and reproduced in Herbert Read's *Art Now*. In February 1934 he staged an unsuccessful show of thirteen of his works in a cellar in Curzon Street.

When the International Surrealist Exhibition to be held in London in the summer of 1936 was in preparation, Bacon was visited as a potential participant by Roland Penrose, but he found the work insufficiently surreal. However, Eric Hall persuaded Agnew's to mount an exhibition of ten *Young British Painters* including

Bacon, Graham Sutherland and Victor Pasmore, which opened in January 1937. A second loyal supporter besides Hall, at that time and later, was Bacon's cousin, Diana Watson.

In 1936 Bacon moved from Royal Hospital Road to the top floor of 1 Glebe Place nearby. Around this time he was probably more active at the gaming tables than at the easel. And during periods when he was painting a great deal, he tended to destroy or abandon the greater part of his output; not until the 1960s did he allow a substantial proportion to survive.

When war broke out Bacon volunteered for Civil Defence and worked full time in the A.R.P. until worsening asthma caused him to give up. To get away from London he spent some time in a cottage he rented with Eric Hall near Petersfield in Hampshire. Late in 1942 he moved into the ground floor of 7 Cromwell Place, South Kensington, formerly the house of John Everett Millais. Here he started producing a series of paintings which were to include his first masterpieces, the *Three Studies for Figures at the Base of a Crucifixion*, 1944, the *Figure in a Landscape*, 1945 and the image of a butcher's shop, *Painting*, 1946. Soon shown in mixed exhibitions, they provoked extreme reactions, mostly revulsion. Those who expressed enthusiasm included Graham Sutherland, who had long been a friend and supporter, and the German immigrant dealer, Erica Brausen, who started buying the paintings one of which she soon sold to Alfred Barr for the Museum of Modern Art, New York. Some of the proceeds of sales, reinforced by winnings at the casino, financed a period in Monte Carlo and nearby resorts.

In November 1949 Bacon had his first one-man show in the West End. Held at the Hanover Gallery, lately opened by Erica Brausen, it consisted mainly of paintings in grisaille. The exhibition occasioned an article by Robert Melville in *Horizon* which perceived Bacon as a major artist.

Following Nanny Lightfoot's death in 1951, Bacon left Cromwell Place as soon as he could; unfortunately, the friend who took over the flat, Robert Buhler, came to sell a number of unfinished or unresolved canvases which Bacon had left behind on the assumption that they would not be put on the market. For the next ten years he worked in temporary studios, mostly borrowed ones, such as a top-lit studio in Michael Astor's house in Chelsea, a small room in a flat in Battersea belonging to Peter Pollock and Paul Danquah, a place in Henley-on-Thames, another in St Ives, and, at the outset, the large studio at the Royal College of Art in South Kensington which Rodrigo Moynihan had at his disposal through being Professor of Painting.

Bacon, in fact, did a brief spell of teaching at the College, diffidently but memorably. He also lunched regularly at its Senior Common Room at a time when it was often called the best club in London and on good days was the point of departure for spontaneous ambulatory drinking parties which could go on, mainly in Soho, for twelve hours, with Bacon footing most of the bills, long before he could afford to. Friendships ripened in the late Forties and the Fifties with Muriel Belcher, Isabel Rawsthorne, Sonia Orwell, Denis Wirth-Miller (his closest friend), Michael Wishart, Lucian Freud, Moynihan, Buhler, Danquah and others; in some cases they were friendships that withered quite soon.

Bacon's foreign travel during the Fifties was, by chance, mainly to Africa. On the one hand, he would go and stay with his mother and his sisters Ianthe and

Winifred, who lived in southern Africa. On the other, he would spend lengthy periods in Tangier so as to keep up with the movements of someone with whom he was having a long, punishing, tormented liaison. Peter Lacy was a former fighter pilot and test pilot with private means who played the piano in bars and was the subject of most of the pictures of men wearing suits widely perceived as business-men and was also manifestly one of the men in *Two Figures*, 1953, the first of Bacon's images of coupling.

Bacon continued exhibiting at the Hanover throughout the 1950s, during which decade he also had his first one-man show in New York, at Durlacher Bros. in 1953, his first in Paris, at the Galerie Rive Droite in 1957, and his first official show, in the British Pavilion at the Venice Biennale in 1954. Despite his understanding with Brausen, shortage of money often persuaded him to sell works – including his first triptych of heads, painted in 1953 – to friends and to other London dealers. In 1960 he started exhibiting with Marlborough, to whom he remained under contract for the rest of his life. He honoured his contract with them, and they relieved him of the burden of tiresome professional chores.

In 1961 he finally found a studio which suited him as well as 7 Cromwell Place, despite being decidedly smaller; it was in fact just around the corner, at 7 Reece Mews. He was to stay until he died.

In 1962 he had his first major museum retrospective, at the Tate Gallery, the first of many such exhibitions around the world. It included the recently-painted *Three Studies for a Crucifixion*, the earliest of his many large triptychs, and also the *Two Figures* of 1953, long considered unexhibitable. On the eve of the exhibition he learned by telegram that Peter Lacy had died in Tangier.

By 1964 he was involved with George Dyer, a rugged young man with a criminal record but the gentlest of temperaments, who inspired most of Bacon's finest paintings of the nude, culminating in a remarkable series of triptychs mourning his death. Dyer's lack of a role in life heightened a drink problem and his relationship with Bacon became increasingly fraught. Heavily dosed with alcohol and drugs, he died in 1971 in a Paris hotel bedroom on the eve of a retrospective at the Grand Palais which for Bacon was surely the most significant exhibition he ever had. Paris was always the city where he longed for success, and he achieved it there, probably more than anywhere, with this exhibition and with his posthumous exhibition at the Centre Pompidou in 1996 and in between with shows at the Galerie Claude Bernard, the Galerie Maeght and the Galerie Lelong, and also through numerous publications by leading writers. Throughout his last twenty years he spent a good deal of time in Paris, with Nadine Haim, Michel Leiris and Jacques Dupin among his friends. Indeed, from 1974 on he had an apartment at 14 rue de Birague by the Place des Vosges.

But he did only a limited amount of work there, something that also happened with properties he acquired at around the same time in England, such as a small house at Wivenhoe near Colchester, close to Denis Wirth-Miller and Richard Chopping, bought in 1972, and a beautiful house in Narrow Street, Limehouse, overlooking the Thames, bought in 1970, where he could do no work at all because of the glitter of sunlight on the water. So, for the last thirty years of his life almost all of his painting was done at Reece Mews.

Age brought a certain amount of surgery, but, with the help of devoted medical attention from his physician, Paul Brass, Bacon's body stood up remarkably well to the pressure put on it by a lifelong love of alcohol. He was still painting hard until two months before his death at 82.

In 1974 he met John Edwards, a darkly handsome East-Ender with whom he formed an enduring relationship that was essentially paternal. He painted numerous portraits of Edwards and Edwards took numerous photographs of him. His last years were lightened by the society of a young, good-looking, cultivated Spaniard whom he was visiting in Madrid when he died on 28 April 1992. John Edwards is his sole heir.

SELECT BIBLIOGRAPHY

Dawn Ades and Andrew Forge, *Francis Bacon*, exhibition catalogue,
Tate Gallery, London, 1985

Lawrence Gowing and Sam Hunter (with foreword by James Demetrion),
Francis Bacon, exhibition catalogue, Hirshhorn Museum and Sculpture Garden,
Smithsonian Institution, Washington DC, in association with Thames and
Hudson Ltd, London, 1989

Michel Leiris, *Francis Bacon: Full Face and in Profile*, Phaidon Press,
London, 1983

Michael Peppiatt, *Francis Bacon: Anatomy of an Enigma*, Weidenfeld &
Nicholson, London, 1996 and Farrar, Straus & Giroux, New York, 1997

John Russell, *Francis Bacon*, 3rd edition, Thames and Hudson Ltd, London
and New York, 1993

David Sylvester, *Interviews with Francis Bacon*, 4th edition, Thames and
Hudson Ltd, London and New York, 1993

LIST OF WORKS

1
Untitled, 1943 or 1944
(variant of the right-hand panel of the triptych
*Three Studies for Figures at the Base of a
Crucifixion*, 1944 in the Tate Gallery)
oil on board
94 x 74 cm
Private collection

2
Figure Study II, 1945–46
oil on canvas
145 x 128.5 cm
Kirklees Metropolitan Council,
Huddersfield Art Gallery

3
Study from the Human Body, 1949
oil on canvas
147 x 134.2 cm
National Gallery of Victoria,
Melbourne, Australia
Purchased 1953

4
Painting, 1950
oil on canvas
198.1 x 132.1 cm
Leeds Museums and Galleries:
City Art Gallery

5
Study for Nude, 1951
oil on canvas
198 x 137 cm
The Collection of Samuel and Ronnie Heyman

6
Portrait of Lucian Freud, 1951
oil on canvas
198 x 137 cm
The Whitworth Art Gallery,
The University of Manchester

7
Study of a Nude, 1952–53
oil on canvas
61 x 51 cm
Robert and Lisa Sainsbury Collection,
University of East Anglia

8
Study for Figure II, 1953/55
oil on canvas
198 x 137 cm
Mr and Mrs J. Tomilson Hill

9
Self-Portrait, 1956
oil on canvas
198 x 137 cm
Private collection
Courtesy Massimo Martino S.A., Lugano

10
Study for a Pope IV, 1961
oil on canvas
152 x 119 cm
Private collection
Courtesy Massimo Martino S.A., Lugano

11
*Henrietta Moraes (Lying Figure with
Hypodermic Syringe)*, 1963
oil on canvas
198 x 145 cm
Private collection

12
Three Figures in a Room, 1964
oil on canvas
each panel 198 x 147 cm
Collections Musée National d'Art Moderne –
Centre de Création Industrielle, Centre
Georges Pompidou, Paris
(Photograph: Philippe Migeat, Photothèque
des collections du MNAM-CCI, Paris)

13
Portrait of Lucian Freud (on orange couch), 1965
oil on canvas
156 x 139 cm
Private collection, Switzerland
Courtesy Thomas Gibson Fine Art Ltd

14
Henrietta Moraes, 1966
oil on canvas
152 x 147 cm
Private collection, London

15
*Version No. 2 of Lying Figure with
Hypodermic Syringe*, 1968
oil on canvas
198 x 147 cm
R. Vanthournout, Belgium

16
Triptych – Studies from the Human Body, 1970
oil on canvas
each panel 198 x 147.5 cm
Private collection

17
Triptych – Studies of the Human Body, 1970
oil on canvas
each panel 198 x 147.5 cm
Marlborough International Fine Art

18
Triptych May–June 1973, 1973
oil on canvas
each panel 198 x 147.5 cm
Private collection, Switzerland

19
Sleeping Figure, 1974
oil on canvas
198 x 147.5 cm
Private collection, New York City

20
Figure in Movement, 1978
oil and pastel on canvas
198 x 147.5 cm
Private collection courtesy of Ivor Braka Ltd,
London

21
Oedipus and the Sphinx after Ingres, 1983
oil on canvas
198 x 147.5 cm
Ivor Braka Ltd, London

22
Figure in Movement, 1985
oil on canvas
198 x 147.5 cm
Private collection

23
Study for Self-Portrait – Triptych 1985–86,
1985–86
oil on canvas
each panel 198 x 147.5 cm
Marlborough International Fine Art